The Grand Union
(1970-1976)

Artists and Issues in the Theatre

August W. Staub
General Editor

Vol. 2

PETER LANG
New York · San Francisco · Bern
Frankfurt am Main · Paris · London

Margaret Hupp Ramsay

The Grand Union (1970-1976)

An Improvisational Performance Group

PETER LANG
New York · San Francisco · Bern
Frankfurt am Main · Paris · London

Library of Congress Cataloging-in-Publication Data

Ramsay, Margaret Hupp
　　The Grand Union (1970-1976) : an improvisational
performance group / Margaret Hupp Ramsay.
　　　　p. cm. – (Artists and issues in the theatre ; vol. 2)
　　Includes bibliographical references.
　　　　I. Grand Union (Performance group)–History.　I. Title.
II. Series: Artists and issues in the theatre ; vol. 2.
GV1786.G65R36　1991　792.8'09'0973–dc20　91-17013
ISBN 0-8204-1547-2　　　　　　　　　　　　CIP
ISSN 1051-9718

Die Deutsche Bibliothek-CIP-Einheitsaufnahme

Ramsay, Margaret Hupp:
The Grand Union : (1970-1976); an improvisational
performance group / Margaret Hupp Ramsay.– New
York ; Berlin ; Bern ; Frankfurt/M ; Paris ; Wien : Lang, 1991
　　(Artists and issues in the theatre ; Vol. 2)
　　ISBN 0-8204-1547-2
NE: GT

The paper in this book meets the guidelines for permanence and
durability of the Committee on Production Guidelines for Book
Longevity of the Council on Library Resources.

© Peter Lang Publishing, Inc., New York 1991

Printed in the United States of America.

DEDICATION

For my son, David

ACKNOWLEDGMENTS

Many people contributed to the completion of this book. First, I am indebted to the members of Grand Union who made themselves available for interviews: Steve Paxton, David Gordon, Douglas Dunn, Barbara Dilley and Nancy Green. Also Mary Overlie, Bruce Hoover, Simone Forti, and Sally and Bill Sommer whose perspectives from outside the performances of Grand Union were so helpful.

My special thanks to Bill Ramsay and Amy Einsohn for editorial assistance and Mimi Johnson and Performing Artservices for making their collected material and photographs of Grand Union available to me.

Finally, my gratitude to the friends who played such important roles in bringing this book to its final form. They include Barbara Mueller and Michele Sumka, as well as Rose Saylin who also helped me select and organize the photographs. I am deeply grateful for their support and encouragement through this whole process.

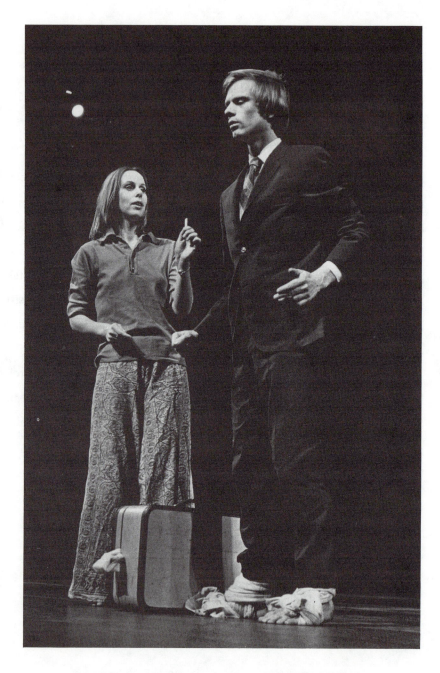

Grand Union: Nancy Lewis Green and Douglas Dunn.
Photo by Robert Alexander.

CONTENTS

Chapter

LIST OF ILLUSTRATIONS

INTRODUCTION

For anyone interested in modern American dance, theater, or performance art, the story of Grand Union is intriguing from several perspectives. In itself, it is the tale of a maverick leaderless collective that developed a radically new, wholly improvisational style of performance. Then, within the story of Grand Union are the intertwined biographies of the ensemble's brilliant and talented core members: Yvonne Rainer, Steve Paxton, David Gordon, Trisha Brown, Douglas Dunn, Barbara Dilley, and Nancy Green. And if we take a step back, we may also read the chronicle of Grand Union as a lively case study in American cultural history of the 1960s and 1970s.

Part of my own interest in Grand Union was stimulated by my work with Free Association, a dance company that I directed and performed with for eight years, from 1974 to 1982. Inspired by the example of Grand Union, Free Association explored the realm of collective improvisation. The freedom I experienced in Free Association, both as a performer and a spectator, was entirely different than any feelings I had had with choreographed dance. The honesty, openness, spontaneity, and unpredictability of the company's creative process clearly had an extraordinary effect on my fellow dancers, on the musicians who collaborated with us, and on a great many of those in the audience.

My desire to recapture and preserve the story of Grand Union was intensified by the fact that the group ended so abruptly, with little fanfare and with little interest on the part of the succeeding generation of dancers. Grand Union stopped performing in 1976 and, in the American fashion of use and discard, by the early

1980s Grand Union seemed all but forgotten. Historically, the art world has a habit of turning its back, at least for a time, on what it doesn't yet understand. But artists and critics have also shown the good sense to return and reinvestigate the prickly and seemingly incomprehensible. Indeed, recently the dance world appears to be catching up to Grand Union. Reverberations of their aesthetic are finding their way into performance art and theater as well.

My research on the Grand Union started with an interview of Douglas Dunn in November 1983. Over the next three years I interviewed almost all the members of the company, the company's stage manager, and several dancers and observers who regularly attended Grand Union performances. Step by step, I pieced together the story: the evolution of the group, the influences on their concepts and work, the structure and content of their performances, their experiences on tour, their interpersonal relationships, and the groups' dissolution.

I was helped considerably in my work by the candidness of the Grand Union members who agreed to be interviewed. Their openness in discussing both the good times and the rough ones bespeaks the same courage, idealism, and humanism that has made their creative lives so rich. Of course, oral history has its weaknesses: all reminiscences are colored by personal perspectives and the passage of time. But in most cases the information given to me by one individual was corroborated by others.

Other indispensable resources included reviews and articles in the dance press, videotapes of performances, and an audiotape description of a performance made by Sally Sommer and William Sommer. Two archival repositories contained invaluable documents: the collection of Artservices, the arts management company that represented Grand Union, and the New York Public Library's Dance Research Collection of the Library and Museum of Performing Arts.

CHAPTER I

IT WAS NEVER CALLED DANCE

A performance by Grand Union usually began with individual warm-ups by some members of the group. Other members casually joined in, music was put on the phonographs, and the dancers responded by moving and talking, spontaneously connecting and reacting to one another, creating and discovering their text and material as they went along. As Sally Banes says in *Terpsichore in Sneakers*, "There were no answers, no goals, no expectations. Just two hours or so to look at some things."[1]

Movement (both dancerly and pedestrian), music, props, costumes and words—from these resources the members of Grand Union each night composed a totally improvised performance. They combined in a collage-like way the aspects of real-life, rehearsal and performance behavior. Like jazz musicians, the performers alternated ensemble, small-group, and solo passages; like circus troupers, they often presented simultaneously overlapping spectacles and segments. The only rule was that every moment be improvised, that nothing could be repeated without modification.

This insistence on open improvisation represented an intriguing new approach to dance. Although many pioneers in modern dance—Isadora Duncan and Loie Fuller, for example—performed improvisationally, until the early 1960s most dancers continued to view improvisation as a technique best suited to the classroom or the choreographer's studio. There, offstage, a dancer or choreographer would use improvisation to discover new material worthy of later refinement. Grand

Union, however, was among the first groups to use open improvisation as its exclusive mode of performance—a daredevil choice that challenged the performers to call upon all their artistry to create something uniquely appropriate to the given moment. As Steve Paxton explains, improvisation requires "the special ability to attack a rigorous discipline as though for the first time, living each moment for its own unique quality. The form is permissive, permutative, elastic, unspecified."[2]

This form of moment-by-moment instinctive choreography excited and challenged both performers and their audience, who sensed the risk being taken and shared in the anticipation and the process of composition in flagrant. Most performance-goers and critics admired the artistic virtuosity and personal strengths that improvisation demanded of the performers: the ability to think, feel, and react spontaneously and immediately to whatever happened by drawing upon all of one's imagination, talent, training, knowledge of dance composition, performing experience, stage presence and confidence. Grand Union's fans rightly suspected that underneath even the most outrageous rough-and-tumble antics, Grand Union was exploring new processes by which art could be made, new approaches for creative discovery and wonder.

Other viewers, however, were more skeptical about the merits of Grand Union's unpredictable "live-ness." In a review published in the *New Yorker* in 1975, Arlene Croce, among the most influential American dance critics of the era, seemed to have enjoyed herself but dismissed the performance as the lightest of entertainments:

> An evening with Grand Union...is a free-for-all of improvised dialogue, shticks, and stunts, much of it funny on purpose, all of it inconsequential, none of it more than incidentally concerned with dancing. The format is so amorphous that no two performances are the same, and so discontinuous that no two descriptions of the same performance are, either. Grand Union['s]...

communal permissiveness makes it perfect campus-cabaret entertainment.[3]

Shticks and Stunts

On one point, at least, Croce is indisputably correct: no two descriptions of a Grand Union performance are the same. But the following montage of excerpts from interviews and reviews is intended to give some flavor of how Grand Union performances appeared to the performers and the audiences:

> Barbara Dilley was at the microphone explaining to the audience that what they were seeing had never been done before and would not be repeated. Just as she says this, David runs to a pillow in the center of the floor, places one elbow on it, pivots around the elbow—and shouts, "Okay, everybody, this is the *second* performance of this." He races back and starts the whole thing over again. "Okay, this is the third performance of this." Steve, Trisha and Nancy all dash for the pillow, leading with elbows, calling out, "A duet," "A trio," "A quartet!" David keeps calling out how many performances "of this." It is instant subversion and transmutation, a quickly changing truth.[4]

> Yvonne walked over, picked up a book and began reading. The material that she was reading was a sexual passage from what seemed like a rather cheapy novel. Douglas and Trish started acting this out. Yvonne was reading very flatly to the mike. Trish and Doug began to act out the instructions of the physical activity that was going on in the narration of the book. There was something about, "She puts her head on his chest at which point she slipped her feet over the top of her head and chest so that the mouth and womb together pressed against his lips." Anyway, it was a physical impossibility to execute the feat. The audience was laughing very hard by this time.[5]

> David Gordon gets up some time after Douglas Dunn has mowed over him with a cushion and says, "There were a

number of ways I could have responded to that. I could have pretended that it was a metaphor for a man getting run over by public transportation. Or, since Doug and I are alike as men we could have represented two slices of rye bread. And the mattress could have been a sandwich. Of course, many people might recognize it as an act of hostility from an enraged competitor."[6]

Steve [Paxton] and several friends came and set a table with candles and flowers and food. They sat down and ate in mirror image with their dinner partner across the table. After a while, they left.[7]

In another scene, David Gordon and Trisha Brown hefted Barbara Dilley and Steve Paxton in front of them like bags of groceries. Gordon then explained: "We'll throw Steve and Barbara in the air. They'll clasp bodies in the air, change places, and come down in our arms again."[8] Of course, the proposed exchange of bodies was impossible. The verbalizing of this gymnastic fantasy, however, was in the telling, an "act" of imagination performed for the amusement of the audience.

Unusual costumes and props, often "found objects" that struck the fancy of one of the performers, inspired all sorts of segments. Bruce Hoover, the stage manager for Grand Union from 1974 to 1976, remembered vividly a performance at the Walker Art Center in Minneapolis:

We had gone out to Sue Weil's home in the afternoon for lunch. It was fall and Douglas got interested in all the leaves which hadn't been raked up, and he gathered up lawn bags of them and put them in the station wagon. Everybody sort of forgot about it, but he brought them to the performance and they ended up covering the entire—almost the entire—lobby at the end of the performance. The company moved all around them.[9]

The *Minnesota Daily* mentioned the leaves and some other props as well:

> The end of the evening starred the props. There were bags of
> autumn leaves dumped out on the stage floor and blown around
> by a fan, a silk shawl, a sofa to move around,...a broom for
> sweeping the leaves into patterns, a closed circuit TV showing
> Grand Union reruns, a platform and some rolling dollies...and
> an outsized, red oriental parasol.[10]

During a company session before a concert, the performers routinely scoured the theater or performance space to see what was available. No one ever planned exactly how to use the performance space, but everyone wanted to see what was on hand. The discovery of unusual props sometimes offered inspiration for performance material.

At one such session before a performance at the University of California, Los Angeles, Douglas Dunn discovered a forklift truck and decided to open the performance with a ballet by the forklift. Dunn gave a stagehand a quick lesson in forklift choreography—"I want you to go upstage, and I want you to now go on a diagonal"[11]—and a short motorized ballet occurred at the beginning of the performance. Another surprise, however, came at the end of the evening. Nancy Green described it:

> We had opened the stage area up—so you could see all the way
> back to where all the equipment was. I left the stage for a
> while. David said, "Where's Nancy?" Then I said to the man
> who had earlier driven the forklift, "Shall we go now?" and we
> got the forklift and drove out on the stage and picked them all
> up, put them on it, and we waved goodbye and drove out
> through the open loading dock at the upstage wall.[12]

Thus the performance space, whether a lobby, a gymnasium, a loft, or a conventional theater inspired the Grand Union members. The adaptability of this improvisational form to unique spatial realities often gave opportunity for invention and surprise.

Costumes

All the members brought costumes and props to performances, but David Gordon's fascination with their effect was an ongoing source of delight. He sometimes devised extraordinarily elaborate make-up and costume get-ups without knowing, of course, how they would fit into the performance. Some evenings David did not appear for the first half hour because he was still preparing a costumed entrance. Deborah Jowitt describes a typically elaborate costume worn by Gordon at the La Mama performance in 1975:

> David Gordon arrived with a stick in his hand and wearing an elaborate costume that suggested a Biblical patriarch; this made for some grand comedy but also, of course, limited his flexibility for a while and determined the ways the others wanted to relate to him. Yet his decision to appear in the trappings of a mournful Bedouin was a perfectly valid and potentially potent Grand Union thing to do.[13]

Gordon usually acquired the costumes by chance:

> I had taken to bringing costume presents to people and somewhere in the middle of the performance saying, "Surprise, look what I have." Well, my grandmother was moving, and I was helping her clean out her house. My grandmother never threw anything away, and I found these 1940 things called playsuits which were navy blue elasticized tube tops attached to pale yellow jersey, very wide shorts, with a very narrow crotch—and I said, "Oh, this will make a great costume for somebody." There were two of them—and I took them and sent them to Barbara.[14]

Later in the performance—a performance in which David Gordon and Steve Paxton had decided to dress and act like twins—Steve, while dancing with Trisha Brown, split his trousers. "If we're going to go on with this," he said, "I have to change my pants." Gordon describes what happened next:

I remember thinking we were twins, he couldn't, [change his pants] unless I did, too. I said, "You can't change your pants. We're twins." Barbara said, "Wait a minute," opened her bag and pulled out the bloomer [playsuit] outfits. I looked at them and I looked at Steve and I knew what those things were. I knew how shy I was about being even partly naked. I knew I didn't have any underwear on. Everything flashed through my head. But we took those bloomers. We said, "We'll be right back," and went to the dressing room. We put the top around our hips and the yellow bloomers hung down to our knees. Meanwhile Trisha runs up to the dressing room and asks, "What music do you want for your entrance?" One of us suggested a Hungarian folk record—that kind of Hungarian music that keeps having ritards. We walked to the top of the stairs and raced down and we did this dance in which Steve twirled me around on the floor, legs out, bloomers everywhere. He tossed me over his shoulder and we did Hungarian dancing and I remember thinking, "What can they make you do that could be more foolish than this?" And at the end—it was clearly the end of the performance and the audience stood and clapped with tears running down their cheeks and I thought, "I guess that was funny." I had goose bumps all over me. It was terrifying, embarrassing, horrible, and we referred to it forever after as the Hungarian Bloomer Dance.[15]

Sally Sommer, who was present at the performance, described this same episode in the context of the evening:

Nothing was working. No one connected. Nancy was obsessed by the hundreds of square pillows. Trish joined her by laying on a stack of them. Nothing. David dropped some of them on Trish. Nancy threw more. Barbara sat on a stack of them. Nothing. Barbara retired. Trish got up to do a duet with Nancy. Nothing. Trish retired. Steve and David changed clothes, to flashy velour pants and matching striped shirts. Nothing. David launched into a TV game show with Nancy and Steve as a soon-to-be-wed couple. "Working together, clear the floor of the pillows by the count of twenty." ("Get rid of those damn pillows.") A chaotic mutually defeating effort at clearing by Steve and Nancy...finally accomplished by count nineteen.

"You lose, but gain the knowledge of cooperative living...and a consolation prize of...Trish." (Whew, it's begun.) Duets: Steve with Barbara, David with Trish. Nancy retrieves, throws pillows at them! Again, and nothing! More attempts to connect with each other. (Trish to Steve: "Where am I? What the hell am I doing here?") Old gymnastic tricks with a ballet bar. Something, but not much, except Steve's pants rip wide open at the crotch. David offers his pants but Barbara offers both the matching skirts. Steve: "I'm game." They rush off. Hungarian music. Will anything work? Suddenly David and Steve burst out into a mad, exhilarated, bizarre, distorted, quasi-cossack, rough-and-tumble melee. It's funny, but just as it might get cutesy drag funny, Steve begins some dangerous flying leaps over the bar and then grabs David into frantic spins...flinging him off the floor into the air, plunging him back down...twirling, twisting, dangling, tangling...but never stopping the frantic dervish of whirling bodies. Collapse. They finish. It worked. Like a volcanic eruption; it worked.[16]

Occasionally, a member of the company would suggest a general costume idea. Steve Paxton, for example, once proposed that at the next performance the only source of illumination be candles attached to hats worn by all the performers. To everyone's amazement, Nancy Green appeared with a sombrero onto which she had mounted a large candelabra. In another performance: "Yvonne [Rainer] donned a pre-arranged costume: red rubber finger sleeves from the stationary store and Kleenex-box 'shoes.' She does a quasi-Katha Kali [sic] number standing on one leg, gesticulating with rubber-capped fingers."[17]

Another source of performance material was the realm of popular entertainment. A satirical poke at TV game shows was a favorite. Usually the master of ceremonies was David Gordon, and the members of Grand Union participated as contestants, foolishly trying to "win" various prizes.

In a performance at the Guthrie Theater in Minneapolis, Gordon began to organize the game by placing brown paper grocery bags in a line on the stage.

With microphone in hand, he initiated a dialogue with Barbara Dilley, who was holding an open, oversized umbrella over her head: "She'll win the refrigerator if she walks through the bags. ...Sorry, little lady, you didn't win this time." Trisha Brown then came forward and began the more difficult feat of attempting to jump with both feet planted in bags—to another set of bags, and another and another. Gordon resumed his patter, "The little lady's going to win a date with Rock Hudson and a trip for two to Tahiti." Another, more complicated challenge was devised for new contestant Douglas Dunn. Although at first he seriously attempted to play this role, he finally ran off into the audience, ending the scene, with Gordon requesting "a rousing hand for our contestants."[18]

Movement

The playoff between theatrical scenes and movement sections was an identifiable element of concerts. Because of their exceptional ability as trained dancers, the company could execute elegant dance movement sections performed in solos, duets, and larger groups. Sally Sommer described Steve Paxton's dancing at the Lo Giudice Gallery in 1972:

> Steve at one point started doing wonderful movement, relaxed quick changes of direction. Tai Chi like—I mean that sort of energy expenditure where the energy of the movement is allowed to put him into something else. A lot of throwing himself into movement really hard and then jerking it to a stop, so that it whips him into a totally new direction. It's a particularly personal style of movement, that's really exciting because it's so unexpected.[19]

And the *Minnesota Daily* review described a long and apparently quite beautiful dance section:

> Dilley and Dunn are moving together in gentle, measured
> nuances. It's simple, small movement: loose arms, bending
> heads, weaving torsos, an occasional foot raised to poise just
> above the ground. It looks deceptively easy, like any one of us
> could do it. What turns the obvious into the exquisite is an
> absolute, almost palpable, sense of communion that pulsates
> between them in silent power. Lewis [Nancy Lewis, also
> known as Nancy Green] who has been working on her own
> elsewhere in the space, edged in between them. For a moment
> it seems as if Dilley and Dunn's communication is going to
> disintegrate; but,...it doesn't. It is transformed instead and
> becomes a trio of spaces and sculpted pauses that edges along
> near the ground. The dancers weave through and around one
> another like three separate ribbons combining to make an
> intricate fancy bow...gradually this snowballs, picking up speed
> and expanding until the entire space is filled with dizzy spirals,
> fast twirlings and rubbery, off balance, flung away arabesques.
> The three of them rush back together and momentarily subside
> in a heap. But before the momentum has been broken, they're
> up and off again, loping in circles around the perimeter of the
> space.[20]

Small subtle movement, large rangey movement—all were explored. "Dunn did a long solo standing still, moving only his mouth—later he added the eyebrows."[21] A face dance by Rainer and Dunn concluded with tongues grotesquely hanging out of their mouths, and at the Dance Gallery, Yvonne did a stripper's bump and grind. A more subtle dance was deftly executed by David Gordon at Wolftrap in Washington, D.C.: "With the smallest of gestures, David Gordon touched his shoulder, his hip, his neck, his ear, and suggested all the narcissistic pop singers who ever lived."[22]

At other times impossible physical feats were approached in a serious, problem-solving manner. The audience watched engrossed, as the Grand Union tempted fate:

> They had then worked out a very complicated thing where
> Barbara wanted to get on Trish's back as Trish squatted. She

wanted to stand on her hips. Barbara was trying to be pulled up from a laying position. It was very difficult. They really couldn't work it out. They couldn't get the strength up to pull the one that was lying down up into a standing position onto the back of the one who was pulling. They then traded places and Trish tried to do it with Barbara. It became rather funny too because Trish would get all wrapped up in these incredible positions and they still wouldn't be able to pull her up. At the end, a resolution of some kind was found, and Trish gestured to the audience with a "ta-dum" as one would at the completion of a circus act, and the audience applauded in approval.[23]

A simpler gymnastic feat was achieved by Barbara Dilley and Trisha Brown at a performance in Tokyo in December 1975. This time Brown provided a running commentary on the proceedings. Dilley lay on her back, legs extended overhead, balancing Brown across her feet, extended horizontally—face-down, arms outstretched, in a "flying angel" position. Brown says:

You will be in a precarious position at least eight feet off the ground. You have to mark the end of it with something. ...Can you put your hands under my rear end? ...I'm even pointing my toes. ...Now, if we come out of this, we could go to the side and you could put me down on my feet...should I arch my back?...[24]

Follow-the-leader warm-ups and movement exercises such as picking up, moving, and rearranging each other like mannequins were created on the spot. Some movement games included specific physical tasks to be attempted by all the company members.

The group starts with a problem: must move fast, maintaining a line formation while carrying and passing numerous props: a thick five-foot rope, a number ten medicine ball, four pillows, a large stuffed round object with a leg attached, a fifty-foot long wooden pole, a folding chair, a black overcoat, a bolt of pink tubular jersey cloth. We trip, fall down, get up, drag each other down and up, keep moving although the "line" very quickly

begins to disintegrate. The bolt of cloth unwinds. Soon we are
pulling and tugging at an amorphous mass of bodies and objects
in a vain effort to keep it "moving." Steve meanwhile has
disappeared into the pink tube and is engaged in a lonely
struggle to reach the other end.[25]

The presentation of strong, almost iconic, images and tableaux was another
aspect of the Grand Union presentation. These images were most often static,
although they were occasionally presented in slow motion. At a concert in
Minneapolis, for example, David Gordon arranged Trisha Brown and Douglas
Dunn in a beach tableau. He placed an oversized Japanese umbrella behind Brown
as she sat on a sheet, then arranged her as though dressing a store window.
(Window dressing was a job Gordon did to support himself.) Douglas joined
Trisha on the sheet, gazing at her while David verbally directed the scene. "Do
you like to make love at the beach?" he asked. Then he moved the umbrella to
obscure them from the audience and added, "Go ahead, we can't see." The two
fellow players ignored him. He continued, "How do you feel about a disappearing
act.?" And then, "Have a nice trip." The light came down to a pin spot on
Gordon's face and he disappeared behind the umbrella.[26]

Despite the apparent randomness and unpredictability of Grand Union's
process, the imaginative creating of material through these varied approaches
brought about performances that were not only original and unusual, but surpris-
ingly cohesive. The overall impression was one of a performance in layers—some-
times dense and complex, at other times as simple as child's play. At its best,
Grand Union achieved a brilliance made possible only by the rigors and freedoms
of improvisation. As Alma Hawkins, a respected dance educator, explains, impro-
visation is a "flight into the unknown" that produces a difficult-to-describe sense
of fulfillment and coherence: "At the end of the [improvisational] experience or
during a fleeting moment within the experience, the creator feels a great sense of

joy, a kind of ecstasy. Suddenly everything seems integrated, and he senses a unity that is profoundly satisfying."[27] Often, too, improvisors find that they have discovered movements or material which seemed beyond their usual capacity, that improvisation elicits a personal response and performance level beyond their expectations.

But Grand Union always ran the risk of failure, and while some Grand Union performances were brilliant, others were boring and even disappointing. That was an accepted "given," Paxton admitted: "We also produced some incredibly bad performances. That seems to be part of the process; I'm not excusing it. I feel sorry for people who went away soured by some experience that we provided."[28] And Robb Baker concurs:

> Not that it always works, as Grand Union members are the first to admit. When you play with chance, you also risk failure. Improvisation is always a gamble, and sometimes Grand Union does lose. The audience may on occasion go away bored if, on some particular night, the chemistry doesn't work.[29]

Failures and missed connections also resulted from the impossibility of each performer seeing what the others were up to at any given moment. When some or all of the other members were out of visual range, the performers had to depend on sound cues—audience laughter, onstage conversations, and the noises made by props being moved about—to keep in touch with the overall progress of the evening's performance. Steve Paxton commented on the demands improvisation placed on his attention and concentration:

> In music improvisation, you could hear all the other elements [instruments] that you are working with. In a dancing impro- visation, you might be working with eight other people, all performing or contributing in some way to an image, and not being able to see it all—what they are contributing.[30]

David Gordon added: "Hopefully, everyone has an eye out for the total picture and is aware of other pictures going on while he's making one of his own."[31]

As we will see, Grand Union continuously incorporated its successes and failures into an evolving aesthetic. An early program note hints at some of the directions the company considered:

> The nature of the group continues to change. Temporary absences (due to travel, the draft, individual concert and teaching obligations) and sudden reappearance affect the work radically. The basic premise seems to be that the situation must be flexible enough to accommodate individual needs at any given time, whether they be about performance, creativity, director-ship, or working alone. Currently we are thinking about organizing many of the ideas and images that emerged this winter into a new structure—partially set and partially impro-vised. The pendulum swing from anarchy, thru "modified democracy," to oligarchy and back again is being carefully observed by all of us.[32]

Even the genre of Grand Union's performances—music, theater, art, dance—was up for debate. Bruce Hoover, stage manager from 1974 to 1976, recalls that all performance contracts stipulated that Grand Union performances were not to be called dance concerts: "They eventually tried to call it performance art, and indeed [in] the publicity sent out, the brochures,...it was never called dance."[33]

NOTES TO CHAPTER I

[1] Sally Banes, *Terpsichore in Sneakers: Post-Modern Dance* (Boston: Houghton Mifflin, 1980) 215.

[2] Steve Paxton, "The Grand Union Improvisational Dance," *The Drama Review* 16 (Sept. 1972): 130.

[3] Arlene Croce, "Going in Circles," *New Yorker* 21 Apr. 1975.

[4] Sally R. Sommer, unpublished notes of viewed performance.

[5] Sally R. Sommer, audiotape description of performance at Lo Giudice Gallery, Apr. 1972.

[6] *Soho Weekly News* 13 June 1974.

[7] Artservices archives, handwritten notes, author unknown.

[8] *Soho Weekly News* 27 Mar. 1975.

[9] Interview with Bruce Hoover, New York City, Mar. 1985.

[10] *Minnesota Daily* 17 Oct. 1975.

[11] Interview with Hoover, Mar. 1985.

[12] Interview with Nancy Green, New York City, Nov. 1984.

[13] *Village Voice* 31 Mar. 1975.

[14] Interview with David Gordon, New York City, Mar. 1985.

[15] Interview with Gordon, Mar. 1985.

[16] Sommer, unpublished notes of viewed performance.

16

[17] Artservices archives, Grand Union Episodes, author unknown.

[18] Transcribed material from videotape of performance at Guthrie Theater, Minneapolis, Minnesota.

[19] Sommer, audiotape description of performance, Apr. 1972.

[20] *Minneapolis Daily* 17 Oct. 1975.

[21] Marcia Siegel, *Watching the Dance Go By* (Boston: Houghton Mifflin, 1977) 322.

[22] *The Washington Post* 23 Aug. 1974.

[23] Sommer, audio tape description of performance.

[24] Transcribed material from videotape of performance at Seibu Theater, Tokyo, Japan (Dec. 1975).

[25] Artservices archives; Episode from a Grand Union performance, handwritten, author unknown.

[26] Videotape, Tokyo, Japan.

[27] Alma Hawkins, *Creating Through Dance* (Englewood Cliffs: Prentice-Hall, 1964) 22.

[28] Interview with Paxton, Dec. 1984.

[29] Robb Baker, "Grand Union: Taking a Chance on Dance," *Dance Magazine* Oct. 1973: 41.

[30] Interview with Paxton, Dec. 1984.

[31] Interview with Gordon, Mar. 1985.

[32] Artservice archives, found manuscript, 1971, author unknown.

[33] Interview with Hoover, Mar. 1985.

CHAPTER II

THE MYTHIC 1960'S

In the United States and in Europe the 1960s was a period of considerable political and social upheaval, a series of convulsive revolutions in values and lifestyle. For American artists and creative intellectuals, it was a time to question everything; as the cliche has it, nothing was sacred. As a collaborative, improvisational group that upended the conventions of dance performance, Grand Union was indeed a child of its times.

The general contours of the sixties era are well known: idealistic social protest in the form of the civil rights movement, the free speech movement, and the antiwar movement, offset by a hopeless fatalism in response to the assassinations of John F. Kennedy, Robert F. Kennedy, and Martin Luther King, the brutal violence in Vietnam, and the long hot summers of rioting in American cities.

Against this national canvas, artists were experimenting with new themes for work, new forms of work, and new ways to work. For example, the federal court's lifting of earlier bans on sexually explicit works by D. H. Lawrence and Henry Miller freed artists to explore themes once deemed obscene, without fear of censorship or prosecution. The spreading interest in Eastern philosophy, particularly Zen Buddhism, suggested formal devices based on indeterminacy, repetition, and a nonjudgmental attitude toward experience: "All things in the world are related and thus relevant to each other."[1] Other artists discovered alternative states of mind and new frontiers for aesthetic experiences by using hallucinogenic drugs.

Three prominent themes of American art in the 1960s had a special influence on the work of Grand Union. First, many artists were attempting to transform the traditionally passive audience or spectator into an active collaborator in the creative process. No longer was art to be safely cordoned off in a museum or on a stage. The purest example of this trend was the kinetic events called Happenings—part theatrical art, part real life. Under this same principle, audience members were invited to be witness to the creative process itself and change their role from voyeurs into participants. Allied with this emphasis on art as a process rather than product was the exaltation of spontaneity and unpredictableness.

A second theme, derived from the work of the Dadaists in the early 1920s, was the use of everyday objects as the basis for artwork. Among the many examples of this post-expressionist trend are Jasper Johns's American flags, Andy Warhol's Campbell soup cans, Roy Lichtenstein's cartoon panels, and Claes Oldenburg's oversized furry ice cream bars. For some artists, the interest in everyday objects extended to working with the new technology of the time.

Third, the group as a collective force was a phenomenon lasting for less than a decade but having a great impact on the art work of the time, providing an alternative supportive community within a social system that traditionally saw the artists as individual genius.

The object of collaboration in an artistic effort was to produce work no one person could create alone. Artists gathered in communes both to live and to produce art work. Some artists attempted to mix aesthetic concerns with the new technology. Important collaborative events such as "The Nine Evenings" (New York, 1966) involved large numbers of artists from various disciplines striving to create unusual breakthroughs, with the help of engineers.

The fact that these collaborations often involved artists from many different disciplines added to the breakthrough quality of the work. The result would later be seen in profound long-term influences on the participants.

Theater, by definition a collective endeavour, was also fertile ground for experimental collective work. The Open Theater, The Living Theater, The Performance Group, Bread and Puppet, Mabou Mines, and the San Francisco Mime Troup were among the many theater collectives active at the time, offering a radically irreverent approach to performing and to nonhierarchical, or leaderless, forms of organizing theater productions.

Beyond these general trends, the force field in which Grand Union was founded included the work of three important postwar choreographers: Merce Cunningham, James Waring, and Anna Halprin.

Merce Cunningham

Merce Cunningham occupies a pivotal piece in dance history. His work belongs chronologically between modern and post-modern dance. In the 1940s and 1950s Cunningham pointed the way toward experimentation with new forms of dance composition; by the late 1960s, in turn, he would come to represent the generation for younger dancers to rebel against. Most of the members of Grand Union studied with Cunningham in the late 1950s, and Douglas Dunn, Steve Paxton, and Barbara Dilley joined his dance company. Working with Cunningham, they would naturally have been exposed to his use of chance as a method of compositional structure and his interest in abstract dance movement as an end in itself, apart from narrative and thematic forms.

Cunningham's theories on chance as a tool for choreography had their seeds in this collaborative work with musician/composer John Cage in the early 1940s.

Cage had already been experimenting with random means to structure his music. By 1945 Cage had begun to study Zen Buddhism and he applied the Zen principles of interrelatedness, randomness, openness, and antidogmatism to his work.

Inspired by Cage, Cunningham created phrases of movement and then allowed a chance procedure such as the toss of a coin to determine which phrases would be performed at which point in the composition. By this system, he also set the amount of time allowed to dance each section. But, as Don McDonagh explains in *The Rise and Fall and Rise of Modern Dance*, "chance is not chaos," and earliest methods of chance composition involved careful preparation:

> "Suite by Chance" (1953) is the first piece in which Cunningham introduced chance into the actual composition of a dance. He prepared a series of dance movement charts for a period of months and then tossed coins to determine which of the movements were to be strung together to make up the choreographic pattern of the dance. Two factors thus entered into the making of a work, and the first was not chance at all, but the selective knowledge of an accomplished choreographer in making the charts, thereby preparing the ground upon which the chance operations could take place. ...[An] important idea in the use of chance is the assumption that chance is an expression of order, although it is not an order that we are accustomed to deal with.[2]

Sometimes Cunningham restructured a dance each time it was performed or combined sections from various dances for a particular performance. Certain choreographed dance phrases might never appear in a given performance, while others might occur repeatedly. At other times, Cunningham explained, "all the sections were to be done at any performance, but the order they were in could be shifted."[3] This concept of composition led Cunningham to various experiments with the myriad possibilities of rearranging the parts of a work.

It is important to distinguish clearly between the "chance" methods that Cunningham used and improvisation. Cunningham's chance methods meant that

the movements were set before the performance, whereas improvisation is, by definition, a form in which the dancer makes choices during the performance. Some of Cunningham's dances did incorporate a kind of structured improvisation, in which the dancers could choose when, where, and for how long each movement was to be performed. Sometimes it was even left to the dancer's imagination how to get on, off, or "over to the other side of the stage."[4] Nonetheless, the freedom to make decisions was at all times given to the dancers—or withheld from them— by Cunningham.

Cunningham sometimes relied on random means for selecting costumes and sets. Inspired by the artist Robert Rauschenberg (his set and costume designer at the time), he asked that in the dance *Story* choreographed in 1963 during a UCLA residency, the costumes be picked from anything useable found in the theater, and the set was to be devised out of whatever was on hand at the time of the performance.[5] Both Steve Paxton and Barbara Dilley were performers in *Story*. Cunningham recently described this dance where bags of costumes were placed offstage and dancers could freely select, change and/or embellish their costume at will. Also, selected entrances and exits were improvised by the dancers within limits set by Cunningham.

Through Robert Dunn, an accompanist at the Cunningham studio in New York City who taught a dance composition class at the studio from 1960 to 1962, a new generation of choreographers began structuring their own dances using Cunningham's methods. The energy unleashed during Dunn's classes, combined with seminal ideas originated on the West Coast, were to provide the impetus for a highly creative and imaginative period of dance activity in New York in the late 1960s. Among those who attended these classes were Yvonne Rainer, Steve Paxton, Trisha Brown, and David Gordon.

James Waring

Another important influence on the members of Grand Union was James Waring, a Californian who had been trained in a variety of dance styles. After serving in World War II, Waring worked with Anna Halprin in San Francisco, where he made his first explorations in choreography. During the 1950s, as a New York dancer and choreographer, Waring inspired and encouraged many young dancers—including Yvonne Rainer, Fred Herko, Deborah Hay, and David Gordon—with his wit and imagination. David Gordon, in recalling Waring's strong influence on his own early choreography, captured one aspect of Waring's appeal and vision:

> Jimmy said, "Everything, anything can happen on the stage. Anything you look at..., anything you choose to put into what you do on the stage is dancing. Never throw away anything. If you don't like it now, you'll get to like it and if you don't get to like it, who says you have to like it," which were Zen and Cage related [ideas]. I took all that information seriously and verbatim and went ahead with it.[6]

Waring's everything and anything included the use of free association to bring together unrelated objects and people in a dance theater of the absurd, allowing for "the juxtaposition of the highly serious and the amusingly inappropriate.[7]

Waring was also challenging conventional ideals about the dancer's body, as Yvonne Rainer put it: "Jimmy had an amazing gift...his company was always full of misfits—they were too short or too fat or too mannered or too inexperienced by any other standards. He had this gift of choosing people who "couldn't do too much in conventional terms."[8] This Waring touch would be seen in much of Rainer's and Gordon's later work, in the value placed on an "everyday" look in manner and form.

But perhaps the most striking aspect of Waring's work was the breaking down of the audience/performer barrier previously "regarded as a sacred gulf across which each retained its own hierarchy of separate but equal privileges. At times dancers would break out of their roles as 'abstract movement machines' to assert themselves as persons."[9]

One reviewer, Doris Herring, was critical of this and said: "When David Gordon and Yvonne Rainer began calling each other by name, the last illusion that this might be a public performance was shattered. The events slipped solidly into focus as a staging of private jokes, private psychoses."[10] The innovative idea of allowing the performer to go back and forth between real and fictitious produced what Rainer called a "performance warp."

By the early 1960s Waring was also collaborating with various happenings artists to create such "dance events" as *At the Hallelujah Gardens* (1963). Choreographed for six dancers, the performance included "a balloon tree, a live goose, performers addressing each other by name, buckets of potatoes, noise-makers, some beautiful solo dances, streamers and paper hoops."[11] The scenery, costumes, objects, and ambient events were prepared by George Brecht, Red Grooms, Al Hansen, Robert Indiana, Larry Poons, Robert Watts, and Robert Whitman. With a painterly sensitivity to images, plus a prolific and eclectic assortment of dance/theater elements, James Waring inspired the next generation of dancers.

Anna Halprin: The West Coast

In the summer of 1960 Trisha Brown and Yvonne Rainer attended Anna Halprin's Dancer's Workshop in San Francisco. There they were introduced to Halprin's use of improvisation as a performance form. Unlike Cunningham's

chance methods, which relied on prearranged phrases, Halprin's workshops discouraged any preconceived ideas of appropriateness and prompted dancers to make movement choices on the spur of the moment.

Simone Forti, a New York dancer and friend of Rainer's who had worked with Halprin in the 1950s and had encouraged Rainer to attend Halprin's workshop, traces the genesis of Grand Union's open improvisational approach directly to Halprin:

> Anna had been doing group improvisational work for a long time. In 1958 or 1959 Anna, A. A. Leath, John Graham, and myself were performing as an [improvisational] group. ...In the summer workshops, all morning would be technique, but the afternoon was improvisational, small groups improvising together. ...I think that work [like Grand Union] started to open up and be worked with in San Francisco with Anna Halprin...it was really a mode that was brought to a certain place and taught in the workshops.[12]

Throughout the 1960s Forti served as a link between Halprin and the East Coast, transmitting Halprin's ideas and later making her own significant impact in the dance community.

For Trisha Brown, Halprin's workshops were lessons in freedom, intuition, and spontaneity:

> Anna created an environment in which her workshop, her person, her analysis, her "verbability" made it possible to go ahead with certain inklings. I think she dealt with almost everything there is to deal with in performance with the exception of ORDER.[13]

Brown was also struck by "the range and capabilities, imagination of those people, that particular group of people":

> I remember one time turning around, and A. A. Leath was making the oddest noise I ever heard a human being make.

> LOUD and REPETITIVE. I thought this guy was a looney-tune. But I stayed with the situation and learned from it. I saw Simone [Forti] do a dance—the moving of her scapula. I learned a lot from that. ...I came from a straight background and a straight education. I was attracted to it and excited by it and confused by it...the invention. The word is creativity. The most extraordinary [creativity was] in the improvisations. I think the primary learning device was the hours, and hours, and hours of working in improvising. Talking and improvising, working into the night.

Like Cage and Waring, Halprin was influenced by Zen Buddhism and its rejection of Western logic, reason, and causality. To escape the "rational trap" of convention and dogma and approach spiritual reality, Zen philosophy encourages practitioners to suspend judgment and seek truth through total openness. For Halprin, one application of this philosophy was to work associatively, allowing one movement or action to follow another without anyone composing a sequence or trying to impose a theme or overview. The fact that one thing happened after another was reason enough to justify it. If a gap appeared, if nothing happened, that was also acceptable. Furthermore, Halprin's goal was to reach a point where life and art were inseparable. To this end, she used untrained dancers and assigned everyday physical tasks as performance material. Trisha Brown recalls: "Anna was working with the choreographic idea of task, such as sweeping with a broom—an ordinary action, organized by an ordinary activity and performed as if you were not performing but off alone somewhere, sweeping up."[14] Back in New York, Simone Forti continued the work on physical tasks as performance by examining rule games as sources for dance. She began this work in 1959 with Trisha Brown, whom she credits with the initial idea, and Dick Levine. She remembers Steve Paxton later joining them in these explorations. Meanwhile Yvonne Rainer was developing and refining other Halprin themes. Robert Morris,

a painter and dance collaborator during the sixties, describes one aspect of Rainer's work after she returned from San Francisco:

> An "associational" approach brought in part from the West Coast where, in the work of Anna Halprin, the materials of the dance are extended to include responses to the streams of consciousness within the heads of dancers...interplays between words and movement.[15]

Judson Dance Theater

In 1962, as an outgrowth of Robert Dunn's composition classes, several young choreographers, including Yvonne Rainer, Steve Paxton, David Gordon, and Trisha Brown, decided to present their experimental work in a concert at the Judson Memorial Church in New York City. This would mark the beginning of what would later be known as the Judson period.

The Judson Dance Theater, as the group came to be called, made one of the most profound, collective changes in dance and choreography in American cultural history. They explored endless ideas of what dance could be: dances were structured like games, play, and even sports; real objects, everyday movement, and nondancers as performers. Visual artists and musicians actively participated as members of the performance group bringing about the integration of objects and other art forms with dance. These mixed-media works as well as a variety of improvisational approaches were tested out. One Judson collaborator was Robert Morris, who had earlier startled audiences with *Column* in 1960: A grey rectangular column measuring eight feet by two feet stood vertically for three-and-a-half minutes, then fell (Morris pulled it with a string), then lay horizontally for three-and-one-half minutes. For Morris, the manipulation of objects became one way to organize a movement piece.

The interest in pedestrian movement led Steve Paxton to recall Judson as his "walking period": "This body of work I would call 'the standing, sitting, and walking work.'"[16] Pedestrian movement was also a keynote of Rainer's *We Shall Run* (1963): "twelve dancers ran to a movement from Berlioz' *Requiem*. Sometimes they ran as a pack, sometimes they divided into groups, sometimes they huddled for an instant."[17] And Rainer explored yet other movement possibilities in *Three Seascapes* (1962), which employed real-life movement and just "doing" a particular set of tasks. This is how Jill Johnston described it:

> In *Three Seascapes*, Miss Rainer makes three incidents...first, she dog-trots all over the stage, and sometimes lies down and gets up, wearing a beach coat, to a luscious and amplified movement from the Rachmaninoff *Second Piano Concerto*. Two, she progresses ONCE across the stage, like a slow-motion spastic, if you can believe it, to the accompaniment of a number of tables and chairs moaning, scraping across the floor in the lobby...and three, she puts her beach coat over a long piece of long gauze, lies down under both, and has a beautiful fit of screaming in a flying mess of coat and gauze.[18]

Another of Rainer's early works, *Terrain* (1963), was structured by rule games. In the first section, "Diagonal,"

> Ten of the movements—which were numbered—could be done by any number of performers, from one to six; four of the choices—designated by letters—could only be performed by one or two. The movements were performed along either of the diagonals bisecting the performing area.[19]

Later in the dance, new rule games were introduced, including one "called Passing and Jostling, in which the performer passed in front of another person, jostled him or her, and stood still until jostled by someone else."[20]

Among the improvisational forms explored by the Judson Group were ones in which sections of a dance were improvised in an open manner, with no

prearranged theme or guidelines and other works based on "spontaneous determination," or structured improvisation, in which dancers freely used preset material within a defined framework. In Elaine Summer's *Instant Chance* (1962), for example, the choreographer gave the dancers a wide range of movement choices and invented a set of arbitrary rules for each performer. The score also allowed one dancer to interrupt another's performance, and large styrofoam dice-like shapes established the instantaneous sequencing of movement content during the performance. Sally Banes describes the rather delightful effect of these unpredictable procedures:

> Watching a reconstruction of *Instant Chance*, I was struck by the child-like nature of the dance. The dancers throw their "dice" as though they were beach balls. ...They rush to perform their actions as soon as the shapes land. The performers' concentration on doing the task at hand—over and over...gives the whole dance the look of a satisfying game. [21]

A free-association game formed the basis for *Association*, by Joseph Schlichter (former husband of Trisha Brown): "The structure was a process of association, in which one person initiated a movement and that activity sparked a chain of reactions, from copying the movement, to varying it, to bouncing from it to a new action by free association." [22]

In the Judson period, then, one could already see the amalgam of attitudes and influences that would shape Grand Union: Cunningham's startling chance method of choreography, James Waring's boldly loose attitudes toward acceptable content, Anna Halprin's experiments with improvisational performance and tasks, Simone Forti's exploration with rule games, and the multimedia real-life happenings staged by artists of the sixties. People, objects, music, and movement could be combined in radically new ways, and during the 1970s several distinct choreographic styles would emerge from this rebellious, explosive, and creative impulse.

One of these styles would be the open improvisational performance work of the collaborative dance company Grand Union.

NOTES TO CHAPTER II

[1] Calvin Tomkins, *The Bride and the Bachelors* (New York: Viking Press, 1965) 129.

[2] Don McDonagh, *The Rise and Fall and Rise of Modern Dance* (New York: The New American Library, 1971) 63–64.

[3] Merce Cunningham, *Changes: Notes on Choreography* ed. Frances Starr (New York: Something Else P, 1968) unpaginated.

[4] Cunningham, *Changes*.

[5] Cunningham, *Changes*.

[6] Interview with David Gordon, New York, Mar. 1985.

[7] McDonagh, *The Rise and Fall* 220.

[8] Yvonne Rainer, *Work 1961–73* (Halifax, Nova Scotia: The Press of the Nova Scotia College of Art and Design; New York; New York UP, 1974) 6.

[9] McDonagh, *The Rise and Fall* 220.

[10] Doris Herring, *Dance Magazine* Mar. 1963: 64.

[11] McDonagh, *The Rise and Fall* 222.

[12] Interview with Simone Forti, New York, Mar. 1985.

[13] Sally Banes, interview with Trisha Brown, 15 Mar. 1977.

[14] Anne Livet, ed., *Contemporary Dance* (New York: Abbeville, 1978) 44.

[15] Robert Morris, unpublished notes on the workshop at James Waring's studio, 30 Oct. 1962. Cited in Sally Banes, "Judson Dance Theater: Democracy's Body, 1962–64," diss., New York U, 1980, 146.

[16] Interview with Steve Paxton, New York, Dec. 1984.

[17] Allen Hughes, quoted in Sally Banes, "Judson Dance Theater" 16.

[18] Jill Johnston, quoted in Sally Banes, "Judson Dance Theater" 167.

[19] Banes, "Judson Dance Theater" 204.

[20] Banes, "Judson Dance Theater" 205.

[21] Banes, "Judson Dance Theater" 93.

[22] Banes, "Judson Dance Theater" 247.

CHAPTER III

IN THE BEGINNING: "EROSION AND RECONSTRUCTION"

The members of Grand Union credit Yvonne Rainer with having created the dance performance form that, between 1968 and 1970, evolved into the Grand Union. The beginnings of that performance style, as we have seen, can be traced to Rainer's early work at Judson, where her first dances were investigations into minimalism and reductionism, explorations using everyday movement and dances built on game structure. As Rainer herself explains, her innovative approach to dance was based on the desanctification of the dancer and the human body:

> It seemed very appropriate for me at that time to use a whole other point of view about the body—that it could even be handled like an object, picked up and carried, and that objects and bodies could be interchangeable.[1]

> It is my overall concern to reveal people as they are engaged in various kinds of activities—alone, with each other, with objects—and to weight the quality of the human body toward that of objects and away from the superstylization of the dancer.[2]

From this premise, Rainer derived a thoroughly iconoclastic prospectus concerning both the form and content of dance:

> No to spectacle no to virtuosity no to transformations and magic and make-believe no to the glamour and transcendency of the star image no to the heroic no to the anti-heroic no to trash imagery no to involvement of performer or spectator no to style no to camp no to seduction of spectator by the wiles of the performer no to eccentricity no to moving or being moved.[3]

From the example of the minimalist sculptors and painters, Rainer also developed an unconventional attitude toward performance as an activity:

> The anti-European, anti-decorative, anti-cultural attitudes of minimal art, and the preoccupation of minimal artists such as Donald Judd, Frank Stella, Robert Morris and Carl Andre with the concept of unity, wholeness and spareness...led me more toward making dance that was involved with task and work rather than exhibition...not showing off my skill but revealing my involvement.[4]

By 1966, when she wrote the "A Quasi Survey of Some 'Minimalist' Tendencies in the Quantitatively Minimal Dance Activity Midst the Plethora, or an Analysis of Trio A," she defined her aesthetic as the reduction of dance to "energy equality, 'found' movement, equality of parts, repetition, discrete events, neutral performance, task or task-like activity, singular action, event, or tone and human scale."[5] One product of these theories was *The Mind Is a Muscle*, first performed in 1965. In a version of *Muscle* staged at the Judson church in 1966, Rainer debuted a four-and-a-half-minute work, *Trio A*, that defied classic dance conventions by having virtually no repetitions of movement: one could view the entire solo as a single phrase. Further, in *Trio A* the rhythm and energy distribution are uninflected, causing an unconventional flattening of dynamics such that even the awkward moments or transitions become equally weighted in importance. The work's constant flow of choreographed movement, performed in a matter-of-fact "doing" of a thing rather than an exhibition-like presentation, precludes any seductive involvement between performer and audience. In keeping with this objective, the performers never looked out toward the audience. The gaze was either averted by looking down, or was directed away because of the demands of the movement.

The Mind Is a Muscle became a much-repeated and elaborated-on dance. In 1968 Jill Johnston described the version presented in New York that spring:

Muscle as it stands now in its one hour and forty-five minute length is in some sense a compendium of Rainer's formal interests. ...There are nine interludes. Two of them, a taped dialogue (conversation) and a pornographic poem...function as verbal equivalents to the dance.... But the musical divertimentos: "Dial M for Murder"—"The Pink Panther" (lush corny movie music)—"Amelia Earhart's Last Flight"—"Strangers in the Night"...plainly throw the flat neutrality of the dance into relief and offer an ironic concession to conventional theatrical expectations. ...Then there are the guys hawking candy during the piece (American Hurrah). And the charming juggler...entertains us on one side of the stage with his battery of tricks while the dancers on the other side alter their configuration as a group in a procession of still lifes or tableaux of a quiet desultory beauty....[6]

Rainer was soon at work on another major piece, *Continuous Project—Altered Daily*, which was first presented in March 1969 at the Pratt Institute by Rainer and Dance Group (including Barbara Dilley, Becky Arnold, Steve Paxton, David Gordon, and Douglas Dunn). It is possible to trace the immediate beginnings of Grand Union to this new work. The dancers performed in the Pratt gymnasium, with the audience seated around the edges.[7] Although *Trio A* made up one part of the program, unlike *The Mind Is a Muscle*, *Continuous Project* was not divided into sections. It was performed as a continuum, one idea flowing into the next. One part described by Robin Hecht, incorporated a series of simple movements:

Two trios of dancers move in a diagonal line across the performing area in the following way: they walk, trip each other up, they run, arms swaying overhead, then they run backward, they run, lift up the middle person; they run, barrel roll the middle person; they hike up on someone's back, then roll somebody over.[8]

And in an ensemble section, "five dancers performed a series of even-tempoed and nonclimactic movements in unison (containing a run, dip, twist, turn, hop, a

cartwheel and a slow walk),"[9] accompanied by an audiotape of Rainer analyzing *Trio A* in terms of its minimalist tendencies.

With *Continuous Project*, Rainer inaugurated a radical change in her work: the sequencing of the dance's content was not fixed; instead, during the performance the dancers discussed what to do next from a list of components Rainer had composed. In retrospect, this opening up of the performance process seems a natural extension of Rainer's concept of dance as "task and work rather than exhibition," but her description of how she arrived at the form of *Continuous Project* also emphasizes how observation in the studio, rather than theoretical conceptualizing, inspired her:

> I'd sort of come to the end of a formalistic use of groups of people. I began to work with five people who had worked for me for some time, and through observing that their contribution to the rehearsals were every bit as interesting as anything I could make, I then got the idea of different levels in that process, in the progress from rehearsal to the finished piece. There were all kinds of possibilities which I formalized by leaving certain material unfinished, making new material in the performance, finishing some material but not rehearsing it sufficiently so it had a rough cast to it in performance. So the whole idea of performance and rehearsal, the whole process seemed opened up and accessible in ways that I hadn't thought about before.[10]

That summer, in residence for two weeks at Connecticut College, Yvonne Rainer and Dance Group taught and performed. Some eighty students were involved in *Connecticut Composite*, which included a version of *Continuous Project—Altered Daily*:

> The dance took place in the Connecticut College gym and the spectators were placed on a balcony overlooking the gym floor. There were five clearly defined performing areas, with different activities going on in each. Down the center length of the room marched Rainer's people wall, a line of people whose task was to walk, shoulder to shoulder, back and forth from one end of

the gym to the other. The solid phalanx—formed eight or more abreast, proved unstoppable; it slid over, under, and around anyone in its way and eventually people from the audience joined in.[11]

From room to room, at will or according to the program, the audience was invited to wander through the performance:

> Trio A was performed continuously in one room of the college gym, while a continuous lecture on the dance played on tape in another room, and films, a "people wall," "people plans," and "audience piece" (Chair-Pillow) and the germinal Continuous Project—Altered Daily were all going on in other rooms.[12]

As the company continued to tour, Continuous Project was altered daily. In fall 1969, during engagements at Amherst College and the University of Missouri at Kansas City, the company came into its own as a collaborative unit. As Steve Paxton wrote:

> First, the group was allowed to participate in ordering the sections; then anyone could bring in music to play for a section; then props could be brought in; then new bits of choreography by the company could be inserted, such as the music or props; and finally, the company discarded several parts of the original Continuous Project—Altered Daily.[13]

And it was in Kansas City that the use of spontaneous behavior as performance material strongly impressed Rainer as a viable possibility. At this time, Paxton recalls, the idea of throwing the entire performance wide open was first discussed:

> Continuous Project was made up of elements which changed according to the spaces we performed in. While we were in Kansas City having a late-night talk about the performance we had just done, I said, "It is very obvious that we are heading for improvisation of material," and thereafter came a long series of responses on how impossible that was. ...In Yvonne's kind of pedantic way of loosening more and more, misunderstandings

would continue until we had assumed more and more functions that she had understood were her own.[14]

Barbara Dilley also remembers the Kansas City performance as marking a turning point:

> People were exploring different ways of putting material together, and she [Yvonne] was encouraging us to explore different ways. I think that the Kansas City performance was probably one of the seminal periods of time for the beginning of what became the Grand Union. We discovered some kind of energy and mutual excitement of creating something on the spot, being original in the moment, and that got us extremely excited, and we stayed up all night talking about it.[15]

But Rainer continued to maintain some type of control over the process, as Douglas Dunn, who had worked with Rainer since 1968, explains:

> *Continuous Project* was altered more and more, having us put things in. Instead of saying, "This is your move," she said, "Next time I want you to bring a move in," or "I want you to bring a bit in," or "I want you to bring a prop in." She still had the authority to tell us to be more active.[16]

Following the Kansas City performances, the members of the company corresponded, sharing their reactions to this new type of performance. For Rainer, the question of control, freedom, and limits was a difficult one: "I am ready to accept total freedom of "response." At this time, I have trepidations about allowing people to "alter" my material or introduce their own, BUT...I give permission to you all to do either of these *at your own risk....*"[17] Despite the creative possibilities of using spontaneous expression in performance, Rainer agonized over how much of a role the company would have in settling procedures and policy.

Six months later, on 31 March, 1 and 2 April 1970, the definitive version of *Continuous Project—Altered Daily* was performed at the Whitney Museum of

American Art in New York. The program lists Barbara Dilley, Becky Arnold, Steve Paxton, David Gordon, Douglas Dunn, Yvonne Rainer, and others.[18] The dancers occupied one performance area, while films were shown in two others, and the audience was invited to move freely among the three areas as long as they did not walk across the main performing space. In detailed program notes (see Appendix A), Rainer described her intentions and the genesis of the work:

> *Continuous Project—Altered Daily* takes its name from a sculptural work by Robert Morris. It has altered and accumulated very gradually since its original presentation as a thirty-minute collection of material at Pratt Institute in March 1969. It was there that I first attempted to invent and teach new material during the performance itself. What ensued was an ongoing effort to examine what goes on in the rehearsal or working out and refining process that normally precedes performance, and a growing skepticism about the necessity to make a clear-cut separation between these two phenomena. A curious byproduct of this change has been the enrichment of the working interactions in the group and the beginning of a realization on my part that various controls that I have clung to are becoming obsolete: such as determining sequence of events and the precise manner in which to do everything. Most significant is the fact that my decisions have become increasingly influenced by the responses of the individual members. Although it cannot be said that *"Continuous Project"* is the result of group decision making as a whole, it is important to point out that there are details throughout the work too numerous to list that should be credited to individual responses and assertiveness other than my own, or to the manner in which we have come to work together, i.e., freely exchanging opinions and associations about the work as it develops.[19]

Another section of the program notes outlined Rainer's analysis of seven "levels" of performance: rehearsal, run-through, working out, surprises, marking, teaching, and behavior. A given performance of *Continuous Project*, she added, could contain any or all of these elements. The program notes also list ninety-two

"roles and metamuscular conditions" available to the performers as performance content, and each performer was also allowed to introduce one chunk of original material per performance.

As staged at the Whitney, *Continuous Project* lasted from ninety minutes to two hours. The sequence of material was determined by the dancers, selecting from present "chunks," some devised as solos, duets, or trios, others requiring the entire group or an indeterminate number of people. Running concurrently with the dance activity, in adjacent areas, two projectors offered the audience a Barbara Stanwyck and Robert Taylor movie, *The Night Walker*, and *Line* by Phil Niblock, both denuded of soundtrack, as well as Michael Fajans's rehearsal film of *Connecticut Composite*.

In his review for *The New York Times*, Don McDonagh cited the strengths and weaknesses of the dance program:

> The overall structure of the piece was a field of nonclimatic activity in which the performers carried, caught and tumbled over one another in friendly competitiveness. ...At times a sequence of dance phrasing would catch on from one to another with an almost contagious joyfulness. Other moments were arid and drained of freshness. The juxtaposition of both were acceptable within Miss Rainer's voracious embrace of all movement full of its own weight and justification.[20]

After a performance of *Continuous Project* at the YMHA in Philadelphia in April, billed as Rainer and Dance Company, the idea of renaming the company was discussed by Rainer and David Gordon. They wanted a name that did not have any dance connotation. She wondered about "Body Shop," he suggested "Rio Grande Union." On returning to New York City, Rainer called Gordon and agreed on "Grand Union." The other members were contacted and casually everyone accepted the new name. But overall, the year of transition, from fall 1969 to fall 1970, from *Continuous Project* to Grand Union, was unsettling. Rainer had

followed through on her pledge to step down as leader, but the company had not yet developed a new process for working together.

> Suddenly we didn't know where we were. We knew Yvonne was no longer leader, and we didn't know anything else. For a while even the group numbers were amorphous. People who had worked with Yvonne in the 1969 Billy Rose concert or in other work came and went. It wasn't clear who Grand Union was going to be at first. There was a kind of shuffling period, when people were deciding whether they wanted to be there if Yvonne wasn't leading. Then as she became no longer the leader there was the question of, could we all deal with each other enough to continue in a group? ...There were also questions regarding structure. How were we going to operate? Were we going to take turns leading? Were we going to rehearse just improvising or were we going to rehearse structures? Different people had different interests. Barbara Dilley wanted to work on semi-structured improvisation, for example— a kind of imitation, a loose imitation. One person does some movement and the other people imitate, simultaneously, but not maybe exactly. We actually rehearsed these things and used those things in performance. ...As I recall it took one and one-half to three years of doing some rehearsing until we came more or less to these decisions. There were six of us left, Steve, David, Barb, Yvonne, Nancy Lewis and myself.[21]

In fall 1970 Grand Union continued its performances in lofts and other nonstage spaces in New York City. From Rainer's correspondence with the members during this period, it appears that she was carefully analyzing these performances and attempting to find out why they worked, which parts were not working, and what kinds of activities produced the kind of work she liked best. Sometimes she functioned, in her phrase, as a "crowd watcher," guiding the performances by turning the music on or off, or going into one of her monologues.

The performers were all struck by the newness of the experience of participating in this radically freer work. They discussed various approaches to interaction: Under what conditions could they interrupt each other? And when

42

could they "sit out"? But even as they wondered about establishing ground rules, they sensed that the core of these early performances was a "reality of encounter" or "truthful response" that they had never before experienced. Rainer expressed her delight and amazement on watching Grand Union perform "behavior" rather than the "execution of movement":

> I got a glimpse of human behavior that my dreams for a better
> life are based on—real, complex, constantly in flux, rich,
> concrete, funny, focussed, immediate, specific, intense, serious
> at times to the point of religiosity, light, diaphanous, silly, and
> many-leveled. We are totally and undeniably there.[22]

"Only on TV," she continued, "does one see live 'behavior' [as performance]. Never in the theater."

The evolution from *Continuous Project* to Grand Union, however, had required the group to slowly relinquish its dependency on Rainer's material as well as her leadership and aesthetic judgment. But despite Rainer's renunciations of leadership, the public perception of Rainer's relationship to the company remained ambiguous. Most of the people booking Grand Union had heard only of Yvonne Rainer and were hiring the company on the basis of her reputation. Members of the company, though, objected to the impression that Grand Union was still Rainer's group. Somewhat belatedly from their point of view, Deborah Jowitt, in a review dated 14 January 1971, announced that Rainer had stepped down as director of Grand Union:

> The Grand Union is Yvonne Rainer's gang. Now officially
> leaderless, Becky Arnold, Douglas Dunn, David Gordon, Nancy
> Green, Barbara Lloyd, Steve Paxton, Yvonne Rainer and Trisha
> Brown, tear Rainer ideas to tatters, worry them, put them
> together, cock-eyed, add their own things. Rainer says, "It's
> not my company." It's hard to tell from her tone of voice
> whether she's relieved or regretful.[23]

Nonetheless, when Grand Union performed at the Walker Art Center in Minneapolis in 1971, the group was called "Yvonne Rainer and Dancers."[24] That November, a letter to Oberlin College from a member of Grand Union, concerning Rainer's recent illness, states clearly the dilemma the company was experiencing:

> Yvonne has every intention of coming to Oberlin. That the hiring of the Grand Union be contingent on her presence, however, raises a thorny issue. It's true Yvonne is the best known of us, but of major importance to all of us, including Yvonne, is that we no longer be dealt with as so-and-so and dance company. Not that we are equal in talent, experience, etc. We don't kid ourselves, but we insist on equal billing from the beginning....[25]

Indeed, as late as October 1972, Rainer felt it necessary to write a letter to *Dance Magazine* in response to Robb Baker's review of a Grand Union performance: "A misconception has dogged the steps of the Grand Union since its inception. Namely, that the Grand Union is Yvonne Rainer's group or that Yvonne Rainer is the director and/or pivotal figure in the company. ALL UNTRUE."[26] Grand Union, Rainer went on to explain, was cooperative and collective in nature and her position was that of "member."

At this time Rainer was continuing to produce and direct other new works, including larger group works that incorporated Grand Union as part of the total piece. The huge game-like work *War* involved thirty-one people, while Grand Union—including Rainer—performed at the same time in an adjacent space. *War* was staged at Douglass College in New Jersey and at New York University in November 1970. Another antiwar piece, in which performers Barbara Dilley, David Gordon, Nancy Green, Steve Paxton, Lincoln Scott, and Rainer wore only American flags, was performed at the Judson Flag Show and at the Smithsonian Institution in Washington, D.C., during this same period.

The most complex admixture of Rainer's own work and that of Grand Union was the dancework, *Grand Union Dreams*, which incorporated objects and images from earlier Grand Union performances. Grand Union members were cast in the roles of "gods," reflecting their relationship to Rainer and their star status, while other dancers represented "mortals" and "heroes," a total of twenty-two performers. For the members of Grand Union, however, *Grand Union Dreams*, performed at the Emmanuel Midtown YMHA on 6 May 1971 forced the issue of the group's work and Rainer's own projects. David Gordon remembers: "We all gave her a hard time during those rehearsals, not wanting to do that work. After that, we kept our personal work very separate from the Grand Union."[27]

Looking back on the origins of Grand Union as an entity distinct from Rainer and Company, Rainer points to the Whitney Museum performance in 1970:

> I no longer formally contributed anything new to the performances but supported and participated in a process of "erosion" and reconstruction as the group slowly abandoned the definitive *Continuous Project* and substituted their own materials. These continued to evolve and change from performance to performance. Within a short time, with the addition of new members, the group became wholly autonomous and the work almost totally improvisational. It became known as "The Grand Union."[28]

NOTES TO CHAPTER III

[1] Liza Bear and Willoughby Sharp, "The Performer as a Persona: An Interview with Yvonne Rainer," *Avalanche* (Summer 1972): 50.

[2] Rainer, *Work* 71.

[3] Yvonne Rainer, "Some Retrospective Notes on a Dance for 10 People and 12 Mattresses Called 'Parts of *Some Sectents*,' at the Wadsworth Atheneum, Hartford, Connecticut, and Judson Memorial Church, New York, March 1965," *Tulane Drama Review* 10 (T-30, Winter 1965): 178.

[4] Rainer quoted in Robin Hecht, "Reflections on the Career of Yvonne Rainer and the Values of Minimal Dance," *Dance Scope* (Fall/Winter 1973–1974): 21.

[5] Yvonne Rainer, "A Quasi Survey of some 'Minimalist' Tendencies in the Quantitatively Minima Dance Activity Midst the Plethora, or an Analysis of Trio A," *Minimalist Art*, ed. Gregory Battcock (New York: E. P. Dutton, 1968) 263–73.

[6] Jill Johnston, "Rainer's Muscle," *Eddy* (Apr. 1968): 40.

[7] Hecht, "Yvonne Rainer" 14.

[8] Hecht, "Yvonne Rainer" 14.

[9] Hecht, "Yvonne Rainer" 14.

[10] Bear and Sharp, "Rainer Interview" 51.

[11] Marcia Siegel, "Dancing in the Trees and Over the Roof Tops," *Judson Review* (Autumn 1971), reprinted in Siegel, *At the Vanishing Point* (New York: Saturday Review Press, 1977) 280.

[12] Banes, *Terpsichore* 52–53.

[13] Steve Paxton, "The Grand Union Improvisational Dance," *The Drama Review* 16 (Sept. 1972): 128–34.

[14] Interview with Paxton, Dec. 1984.

[15] Interview with Barbara Dilley, New York, Nov. 1984.

[16] Interview with Douglas Dunn, New York, Nov. 1983.

[17] Rainer, *Work* 149.

[18] The "others" were Annette Michelson, Carrie Oyama, George Sugarman, Hollis Frampton, Lucinda Childs, Naomi Fire, and Richard Foreman, who read various texts at the microphone.

[19] Yvonne Rainer, program notes, Whitney performance of *Continuous Project—Altered Daily* 31 Mar., 1 and 2 Apr. 1970.

[20] *The New York Times* 1 Apr. 1970.

[21] Interview with Dunn, Nov. 1983.

[22] Rainer, *Work* 148.

[23] *Village Voice* 14 Jan. 1971.

[24] Suzanne Weil, former director of the Walker Art Center, telephone conversation, Apr. 1985.

[25] Letter to Brenda Way, Oberlin College, by Grand Union member (probably Douglas Dunn), 5 Nov. 1971.

[26] *Dance Magazine* Oct. 1972.

[27] Banes, *Terpsichore* 223.

[28] Rainer, *Work* 125.

CHAPTER IV

ON TOUR

At the time the name Grand Union was chosen, in the fall of 1970, the members of the company were a loosely grouped assortment of people who had worked with Yvonne Rainer over the past several years. By spring 1971 the company's membership had temporarily stabilized at eight: Rainer, Steve Paxton, Douglas Dunn, David Gordon, Barbara Lloyd Dilley, Becky Arnold, Trisha Brown, and Nancy Green.[1] In an early article on Grand Union, Paxton includes Lincoln Scott (who went by the name Dong) as a founding member,[2] but by the end of 1972 Dong, along with Arnold, had left the company and Rainer had begun to disassociate herself from it.

Grand Union ushered in 1971 with a number of loft performances in Greenwich Village and three benefit performances at New York University and St. Peter's Church to raise funds for the Black Panther Defense Committee.[3] In February, while Rainer was in India, the company rehearsed and performed at a loft space on 13th Street. Barbara Dilley recalls:

> We would rehearse there, and then perform there on weekends.
> We did a whole series...about five weekends—like Thursday,
> Friday, Saturday, three or four days each weekend. It was just
> exhausting. We had very small audiences...maybe twelve people
> in the audiences.[4]

A Grand Union performance in March 1971 at dancer Laura Dean's loft on Crosby Street was reviewed by Deborah Jowitt for the *Village Voice*. Jowitt was struck by

the company's offhanded, seamless transition from setting up the space to performing—a way of beginning that became a company trademark:

> Only three members in sight: David Gordon, Barbara Dilley, Douglas Dunn. ...Desultory stretching, arranging of mats for people to sit on, screwing in of bulbs. Someone puts on music, and Barbara Dilley is off and dancing. ...Other Grand Unioners arrive with the audience—not all of them though. Maybe in a cooperative, you can opt whether or not to show up. ...They warm up with a follow-the-leader improvisation, changing leaders from time to time. ...I notice that the Grand Union's approach to improvisation is very organic. ...They often latch onto a kind of movement that pleases them and play with it, developing it slowly, letting it evolve or break off into something else when they are ready.[5]

May 1971 found Grand Union in residency at the Walker Art Center in Minneapolis. Suzanne Weil, the center's performing arts coordinator and one of the most innovative dance sponsors outside New York City, had been supportive of Rainer's early work and eagerly invited Grand Union for five days of lecture-demonstrations and performances. The residency was funded in part by the National Endowment for the Arts, which in 1970 had introduced a program whereby sponsoring organizations such as colleges and art centers could apply for a dance company to be in residence, and the NEA would underwrite a third of the company's fee.[6] (This successful NEA program was, unfortunately, discontinued in 1983.)

Weil, who had been known to hold rock concerts in order to cross-subsidize dance performances, housed the Grand Union at her home during their stay and made all the center's resources available to them. The residency included lecture-demonstrations and performances by Grand Union, and several individual members of the company developed large new pieces using local performers. Grand Union staged one event in the lobby of the Walker and drew a favorable response from

the *Minneapolis Tribune*: "It was challenging, fun, at times amazing, not something enjoyable in the usual sense, but provocative, the kind of thing the Walker does best."[7] One sequence described by the *Tribune* nicely captures the playfulness of the evening, part shtick, part wit:

> The dancers chant and sing and laugh, while a hippopotamus sculpture stands serene in the middle of the floor (until it is tipped and a leg breaks off, prompting Miss Rainer to stick it down her front and play with it inside her blouse, which prompts Gordon to feign a German accent and demand to remove the lump surgically, which causes everyone to break up).

During the summer of 1971 the company traveled to California and performed at the San Francisco Art Institute. Barbara Dilley described the outdoor performance as "far out"; David Gordon's recollection of Dilley's entrance illustrates how far it went:

> [It] was a very long performance on the roof...and we all performed on these concrete steps except for Barbara, who came out, I think, naked, covered in mud with feathers stuck onto her...and she slowly climbed along a concrete incline in back of the audience.[8]

The following January, another NEA dance-touring grant allowed Oberlin College to host Grand Union for a twenty-day residency. During this extended stay, there were Grand Union performances, members of the company presented concert work of their own, and classes were taught. The students' reactions to the classes, however, illustrated the difficulties Grand Union was facing in getting serious attention for their new dance form, as David Gordon explained:

> We were always hired by dance departments, and what they really wanted you to do was to give [dance technique] classes. There was barely anybody [in Grand Union] who taught anything you could call technique. Barbara [Dilley] used to when

> we first went out—she would allow herself to teach Cunningham [technique]. Nancy [Green] would teach Limon, and Steve [Paxton] liked teaching contact improvisation. We got to where we insisted on one performance preceding any teaching, so that the people who came to the class had some idea of what we did. ...Inevitably they came in and were disappointed because it wasn't a college technique class.[9]

Only once, during a residency at San Diego State College the following year, did Grand Union teach a class together as a group. And once was enough for David Gordon:

> I don't want any part of that situation. I think the others enjoyed it, but I found it just too difficult. I'm not interested in a lot of the material they are interested in giving, as class—and I find it frustrating to stand around watching—because your turn is coming up and you don't know when.[10]

The relatively long stay at Oberlin, however, proved to be conducive to company members' developing new individual projects within their classes. They had access to what seemed—in comparison with the New York dance scene—an abundance of dancers, rehearsal time, and space. Here Steve Paxton began working with a group of eight male student dancers on an extremely physical form of dance improvisation that would later be called "Contact Improvisation." And David Gordon used the residency to create a new dance work, rather than teach a class:

> I'd have a captive crew of people who would be the cast, so that I was able to work with twenty-five to forty people and make a new piece. I had specific rehearsal times and a performance date. So I was able to get intensely involved in making work [of my own].[11]

Back in New York, another teaching opportunity presented itself when Grand Union was collectively invited by New York University to teach a course. Most

of these classes were conducted by Barbara Dilley and David Gordon, with some other members teaching an occasional session.

However, even as the company was gaining recognition and good reviews, Yvonne Rainer was becoming more involved in film making and less interested in performing with Grand Union. Ongoing health problems and the pressures of improvisational work also influenced Rainer's decision to loosen her ties to the company. In an interview published in *Art Forum* (December 1972), Rainer expressed some dissatisfaction with the direction Grand Union was taking: "Well, a good part of the time I'm not sure I want to be there, and I'm sure all of us have experienced that at one time or another. The pressure to put out under such conditions can be killing.'[12]

> [Rainer] Trisha, do you agree with this? The Grand Union has gotten into a kind of crowd-pleasing. We are aware when the audience is with us or not—
> [Trisha Brown] We've gone for the belly-laughs instead of—
> [Y.R.] The long haul! (general laughter)
> [T.B.] Humor is a safe solution to a sticky problem.[13]

Theater director, Richard Foreman, another participant in this group interview, seconded Rainer's concerns:

> Lately I've been rather perplexed by what I've seen of the Grand Union. I've noticed—and others who don't know you personally have expressed similar sentiments in my presence—a kind of in-group jokiness that seems on the verge of dominating the performance.

Later, in 1985, Rainer noted: "Grand Union in the early '70s was so exciting... invention and erasure happening simultaneously. For me, of course, this was also a big frustration. We never rehearsed. It [finally] became too dangerous for me."[14] Although she continued to appear occasionally with the company, Rainer's full-time membership in Grand Union ended in May 1972, after Grand Union

completed a series of three performances at the now-defunct Lo Giudice Gallery on Wooster Street.

At the suggestion of Trisha Brown, Carlotta Schoolman, an administrator at the Kitchen Center for Video and Music in New York and a self-described fan of the company, had all three Lo Giudice performances videotaped.[15] Schoolman had first seen Grand Union at the 12th Street loft performances and was fascinated by the group's performance structure; for her, it was the most exciting, innovative, "in" performance work at the time. Many dance critics were equally enthusiastic about Grand Union's work during 1972. Robb Baker, writing for *Dance Magazine*, said he could "recall seldom—if ever—seeing anyone dance more—or harder—or better than the seven dancers of the Grand Union," and Don McDonagh, for the *New York Times*, was captivated by the "imaginative variety of [the] improvisational evenings," though he complained about the length of the performances.[16]

Despite good reviews and the continued support of the NEA, the company did very little college touring in 1972–73; other than the Oberlin residency, the only two college bookings were at the Stony Brook campus of SUNY (6 May 1972) and a half-week residency at Buffalo State College (22-24 September 1973).

The company was far from idle, though. Early 1973 was devoted to organizing a two-month festival of dance, music, and mixed-media works at the Dance Gallery, 242 East 14th Street. During April and May, Grand Union gave seventeen performances as their contribution to the festival. The company now had six regulars—Trisha Brown, Douglas Dunn, Nancy Green, David Gordon, Barbara Dilley, and Steve Paxton. Yvonne Rainer appeared in two of the performances but announced that she was channeling her energies into her own activities, not Grand Union's.[17] The Dance Gallery series also featured performances by Barbara Dilley's improvisational dance company, The Natural History

of the American Dancer, as well as an evening of Contact Improvisation and solo evenings by David Gordon and Steve Paxton. A total of twenty-three other artists joined in for various events.

Because the Dance Gallery series was financed in part by a $3,000 grant from the New York State Council on the Arts, Artservices, Grand Union's management company, was required to file a report with the council at the conclusion of the festival. According to the report—"The Grand Union and Friends and Associates in Two Months of Performing and Carrying On"—an average of forty to fifty people attended each performance, with many audience members returning for several performances.[18] And on the last evening a record crowd of about two hundred very enthusiastic people jammed into the space to see Grand Union. As Nancy Green described the audience, they were "just warm, just hot...[already] seeing what this work was going to become."[19]

Press coverage for the Dance Gallery series had been uneven, however, a disappointment that still rankled David Gordon over a decade later:

> We tried desperately through everybody who anybody knew, to get the theater critic of the *Village Voice* to come and review performances of the Grand Union. The *Village Voice* refused to print the theater critic's review because we were not a theater group. We were a dance group. All advertising was basically word-of-mouth, and we printed a calendar and sent it out. Deborah Jowitt came to the *thirteenth* performance.[20]

The report prepared by Artservices, however, outlined a more comprehensive promotional effort than Gordon recalled:

> During the third week of March, a press release advertising the festival generally was sent out to twenty-one news media. The same week, a five column by two inch ad was run in the *Village Voice*. During the last week of March, one hundred posters, listing the performance schedule as completely as possible, were printed, about fifty of which got posted around the city. For the

rest of the festival, a weekly two column by one and one-half
inch ad was run in the *Village Voice*, listing the performances
of that week. Complete listings of every performance were run
in the *New York Times* dance and music calendars, *New York
Magazine* calendar, and What's On page of the *Village Voice*.
In mid-April, one thousand flyers were mailed out to supplement
existing publicity.

Meanwhile, due to effective management by Artservices and the continued

support of the NEA touring program, Grand Union's touring schedule was filled

for 1974. In January the company appeared at the Contemporanea Festival in

Rome, Italy, an established performance festival staged in an underground garage

at the Villa Borghese. "I couldn't believe it," Douglas Dunn commented, as he

recalled the same room where the festival took place: "Really thin walls in a cold

damp concrete parking lot underneath a park."[21] David Gordon remembered the

size of the audiences:

> The Grand Union went to Rome for as much money as we could
> get out of them, which was not very much, and arrived there to
> do four performances on the night of Trisha's final performance
> and found forty people in Trisha's audience and found fifty on
> our first night and two-hundred people on our last night through
> word of mouth, not through publicity, and that was the maxi-
> mum audience we could reach.[22]

That same winter a three-university NEA-cosponsored tour was booked: a

week's residency and two performances at the Annenberg Center at the University

of Pennsylvania (9-10 February 1974), five days of teaching classes and performing

at San Diego State University (24-28 February), and two evening performances at

the Center for the Performing Arts at the University of Iowa (8 March). In all, it

was a financially and critically successful tour.

Grand Union's return to New York in the spring of 1974 was noteworthy for

the packed calendar of performances, with appearances at three local colleges in

one week—Pratt Institute, SUNY at Stony Brook, and Barnard College. In May the six regulars minus Steve Paxton appeared for two evenings at The Kitchen, dazzling the critics. Robb Baker, writing for *Dance Magazine*, correctly linked the quality of the Kitchen performances with the amount of time the company had spent together:

> As with the group's two-month stay at the Dance Gallery in the Spring '73, it seems the more they perform together in a single span of time, the better they get, communication builds, connections come faster and faster, everything gets more and more cohesive...by the fifth performance (the second night at The Kitchen) things were so tight that it was like witnessing the whole diction process (shorthand, transcription and the typing of the final draft) without a break, telescoped in a single flash.[23]

And Kathy Duncan, writing in the *Soho Weekly News* (13 June 1974), reported that the company had grown into a "collective genius, one of the finest improvisation ensembles around" and that "their sense of timing has been refined to perfection."

While the critics were awed by the discipline, timing, and cohesiveness of the New York performances, a few members of the audience seemed to think that Grand Union's casual, fun, anything-is-OK mood meant that *any*one could get up and do *any*thing, and several spectators tried to insert themselves into the act. At Pratt, for example, five kids began "rolling oranges, exhibiting their yoyo expertise, funky-chickening it up to the record-player sound of 'bright, bright sunshiney day.'"[24] While Trisha Brown tried to intimidate the intruders into retreating, Douglas Dunn and Steve Paxton ignored the heckling, and Nancy Green and Barbara Dilley smiled shyly at the kids. When all these strategies proved unsuccessful, the six performers sat themselves down in the audience and watched their challengers—a response in keeping with the Grand Union way of doing things.

Strangely enough, another intrusion occurred the same month at the Kitchen performances, when Laleen Jayamanue, a dancer and friend of Douglas Dunn, attempted to join in. At Trisha Brown's suggestion that Jayamanue "could get a group of [her] own together and call it the A&P," the audience laughed loudly and Laleen returned to her seat.[25]

A different kind of problem with audiences marked the company's week-long residency at the Lewiston State Art Park in New York during the summer of 1974. In order to generate income, Grand Union accepted a wide range of bookings, some of which were not exactly conducive to presenting dance work. "Art Park taught us an incredible amount," is how David Gordon prefaced his funny, yet painful cautionary tale of frustration and triumph:

> We were supposed to perform in an outdoor space. We were supposed to do what they call rehearse, but...what they call rehearse is performance for us, so we were supposed to go and work in this outdoor space in which they set up a dance floor right next to the hot-dog stand, and people came by and bought hot dogs and wandered off to look at the park, while we stood out there doing that stuff that couldn't be heard and.... The second day we were there it rained, and it rained every after-noon from then on. So we were taken and put inside the theater, on the stage. There was not a sign out anywhere in that park saying that we were working on the stage. We played to seven old ladies with a tour guide, who made their way through the twenty-five-hundred-seat amphitheater to go out the other side. [The guide said:] "This is the auditorium and here is a group working on the stage"...then they were gone, and we were still working. We played to the stagehands, five stage-hands and they were our audience. They thought we were dynamite. They could hardly wait for the next day to get back and see what we would do next. They put up handwritten signs saying Come In. It was terrific, and they were all like forty- to fifty-year-old tradesmen from town, carpenters and plumbers.[26]

At the end of August, Grand Union performed at Wolf Trap Farm Park, a large new theater near Washington, D.C. The performance was poorly received by the audience, and reviews were mixed. A handful of people attended, and half of them left at intermission. The program had been advertised as a collaboration between Grand Union and the music group Musica Electronica Viva of New York. But the two groups merely shared the program, with the first half being a long improvised musical piece, the second half Grand Union. One local critic described the evening as "lifeless Living Theater": "I know there seems to be some sort of cult for this group and its founder, but really...."[27] In contrast, the *Washington Post's* reviewer beamed: "Those who left missed one of the wittiest, liveliest, far-out dance performances I have seen. ...When the Grand Union dancers took over after intermission, they brought a rich mixture of fantasy, parody, games and reality."[28]

Meet the Press

During the early 1970s members of Grand Union had more than once been disappointed by and frustrated with the dance and theater press over the extent and type of coverage the company received. Some critics, the company members felt, were pigeonholing Grand Union as light entertainment, comparing them to comedy improv groups like Chicago's Second City. Members of the company were dismayed to read glowing praise for their ability to "improvise a routine as easily as nightclub comedians can create skits out of chance phrases" (Don McDonagh, *New York Times* 3 April 1973) or appreciations based on their performance having been "as accessible and entertaining as a nightclub act" (Kathy Duncan, *Soho Weekly* 13 June 1974).

Such long-simmering tensions and misunderstandings led Grand Union to call a meeting between themselves, the New York dance critics, and other "interested souls." On an October afternoon in 1974, the six regulars minus Steve Paxton met with critics Deborah Jowitt, Marcia Siegel, Robb Baker, Don McDonagh, Kathy Duncan, John Howell, Andy Mann, and Robert Pierce; dancers Carolyn Brown, Sara Rudner, and Valda Setterfield were also there, along with photographer James Klosty.

David Gordon stated the problem to the critics:

> There doesn't seem yet to be a difference between the language that described or deals with conventional choreography and the language that deals with information that is being transmitted in a very different way. If we were doing equivalent work in painting or sculpture, we would be dealt with as revolutionaries. Instead, we are dealt with as light entertainment. ...The other possibility is that they [the critics] come a lot of times, decide what it is and box it.[29]

The discussion turned to the problems created by the spectator or critic observing the performer behaving and being "real" while still "doing the show" and the resulting confusion and difficulty in describing these simultaneous events. As the critics and Grand Union discussed the company's work, they touched upon how the company dealt with music and props, the performers' intentions, and the difficulties of describing the various levels of their performance. Deborah Jowitt commented: "Grand Union is doing something on two levels: You're doing the show, which you're hoping will work, in whatever sense you mean by that, and you're also being or not being yourselves at any given moment."[30]

One outcome of this meeting was an in-depth article on Grand Union in *Dance Magazine*. Much later a heavily edited transcript of the meeting appeared in the *Soho Weekly News* (29 April 1976). But the critics' enhanced awareness of the peculiar nature and structure of Grand Union's work did not necessarily

translate into more articulate or insightful reviews. While a few critics did abandon the traditional, accepted ways of looking at dance and attempt to describe Grand Union's pioneering new performance form, others continued to pigeonhole the group and stereotype individual performers into expected roles. Equally dismaying to the company was the reviewers' tendency to write about the obvious comedic or bizarre aspects of the performances rather than the elegant, beautiful moments and their propensity to ignore the most important feature of Grand Union's work: the subtle interplay between the various facets of the form and the sometimes raw collision of content.

Attaining—and Upending—a Delicate Balance

In March 1975 Grand Union did their first performance series at the La Mama Annex in New York. Judging from the reviews and the attendance, the company was at the peak of its form. The audiences were receptive, and the group received several long reviews from the New York papers, reflecting the hard-won acceptance, respect, and following they had earned within the community of intellectuals, artists, and dancers. Furthermore, the La Mama audiences were consistently large, as Bruce Hoover recalls: "My memory is it was always packed, which meant 250–300 people, people jammed in and sitting on cushions on the floor and all around the sides—everywhere."[31] "The March 15th performance was by any standards a brilliant one," Deborah Jowitt wrote, but "the March 16th one kept getting snarled."[32] Apparently the snarl was David Gordon's elaborate costume, the trappings of a mournful bedouin, which limited the members of the company in relating to him—and limited his possibilities as well. A memorable moment described in more than one review was Nancy Green's standing for an interminable time "way at the back, up on a little stage, with a blue blanket over

her head and finally (in a propitious silence) asking in her high quavery voice, 'Am I doing something important?'"[33]

In fall 1975 the company returned to the Walker Art Center in Minneapolis for a week's residency and two performances, the first at the Guthrie Theater, the second in the Walker Art Center lobby. This repeat visit was very different from the first, however. Attendance at the first performance was sparse, mostly local dancers, and the *Minneapolis Star* called the concert disappointing, excessive (at 110 minutes) and self-indulgent. The *Minnesota Daily*, in a longer piece that covered both performances, expressed the opinion that this was not Grand Union's best week and found the company "mired or wallowing in corny dialogue, stock situations and sophomoric anecdotes."[34]

The performance in the Walker Art Center lobby was apparently more successful and more cohesive, but the *Minnesota Daily* reviewer again criticized the overly silly wordplay and the company's self-indulgence in prolonging the concert beyond its natural length: "The first of the endings showed up before 9:45, but it wasn't until half-an-hour later that things finally stopped. This last thirty minutes was blatantly overworked."

The consensus among reviewers in Minneapolis was that Grand Union had lost touch with the movement-oriented basis of their performance and had upset the balance between theatrical elements, verbal play, and dance: "They carry on conversations, some audible, some not. Most of them are either terribly silly or spiced with Johnny Carson double entendre."[35] "The bizarre juxtaposition of the Union's sophisticated sense of movement with a cute and really hardly very interesting wordplay doesn't just limit the amount of the movement...it actually waters down the movement's inherent power."[36]

An unusual opportunity to regain that balance came in the form of two concerts in Tokyo, Japan, in December 1975. Grand Union had been invited to

perform at the "Tokyo Dance Today Festival," held at the Seibu Theater, a five-hundred-seat auditorium on the top floor of a department store—not an unusual place for a theater in Japan. The store owner sponsoring this postmodern dance series had arranged for several contemporary dance companies to appear; Trisha Brown and David Gordon gave concerts of their individual work, as did the American dancer Simone Forti.

Though dance and music are often called international languages, Grand Union's blend of movement, sound, and wordplay seemed to require that some elements of translation be included in the Tokyo concerts. As stage manager Bruce Hoover recalled:

> For some reason somebody decided that it would be interesting to take a transcript of a previous Grand Union performance, someplace in America, which somebody had, and have that translated into Japanese, and played over the sound system as the audience was coming in. It was not explained to the audience. They merely heard this dialogue.[37]

The company also enlisted an American Jesuit priest, Father Joseph Love, to translate during the performance. Father Love, who had lived in Japan for over a decade, cautioned the Grand Union members about cultural differences and decorum. The Japanese, he said, were not used to hearing certain words spoken in public—obscenities—the cultural differences precluded this. However, Bruce Hoover remembered the following incident:

> Father Love told me afterwards that somebody [in Grand Union] used the word "fart," which probably nobody even thought of as an obscenity. It was just a word. ...Father Love told me that he did not translate that [because it] would have been one of the worst things he could have said in public in Japan.

The problems of cross-cultural communication, however, could be turned into usable material for performance, as a videotape of this Tokyo performance

reveals. The concert begins with the warming up by loosely dancing around the vast stage. Steve Paxton tells the audience about another performance when Barbara Dilley was depressed and had cried in the afternoon. Douglas Dunn is wearing street clothes and a cowboy hat; he looks like a clean-cut country boy. Dunn repeats some simple movements, smoothly developing them into longer phrases of dance movement. He performs slow, smooth turns with long extended arms and legs. A spotlight focuses on him, when David Gordon suddenly appears with yards and yards of rope. Gordon begins to twirl the rope and successfully lassoes Dunn. This turns into a long performance sequence involving the play of "weight leans" against the pull of the rope. The two men pose in various attitudes incorporating the long rope. They announce a title for each pose—"This one is serious," "This is called the camels going to the mountain," "This is called the bird on the branch"—and the audience laughs, recognizing the humorous twist on the Japanese practice of playfully titling art works.

Now the lighting begins to illuminate different areas of the stage. There are platforms and a small set of steps, the kind tap dancers use in stage routines. Soon the steps have been lassoed and are pulled about the stage in and out of the light and shadows. Paxton says, "The camel sees its reflection." He continues giving the posed steps ludicrous titles: "The mother kangaroo and her teenage son."

Bruce Hoover remembers another standout section from one of the Tokyo performances:

> It was the only time it happened to my knowledge, everybody did a solo. It wasn't thought of beforehand. It just happened. Somebody did a dance. Somebody else got up and did a dance, and it just evolved. David was the only person who hadn't done a dance, and everybody else was sitting down on stage, and there was David with everybody else looking at him, and he got up and did this terrific monologue about "What do you think I am? Crazy? You think I'm going to follow these people? These people are extraordinary dancers. I can't dance like that.

I'm not going to do that," and he went on for about five minutes, saying he couldn't dance and he wasn't going to do any of that stuff, and it was wonderful, of course—it was his solo.[38]

The awkwardness of simultaneous translation led the company to do more dancing and more manipulating of objects than they had been doing in their U.S. concerts. As Hoover describes it: "They dragged a lot of junk out onstage. I remember lockers being dragged onstage and Nancy being inside one of them, inside one of those little tiny coat lockers. She'd jammed herself into it."

In Tokyo then, faced with the challenge of performing before a non-English-speaking audience, Grand Union was forced to depend more on movement material, thus regaining the balance between the elements of their form. As to the Japanese reaction to these performances, Bruce Hoover says, "I don't think we ever knew, even after it was over. Japanese audiences are polite. There was always polite applause."

But the audience response was more than polite when Grand Union presented four performances to packed houses at La Mama Annex, 22–25 April 1976. With Steve Paxton away on a teaching engagement and Trisha Brown wanting to concentrate on her own choreography, these concerts featured a change in the regular group of performers: Barbara Dilley, Nancy Green, Douglas Dunn, and David Gordon were joined by Valda Setterfield. Setterfield, David Gordon's wife, had been invited to perform at the La Mama series because, as Douglas Dunn remembers, "Someone was missing. We asked her in because Trisha wasn't available or didn't want to do them—I don't remember. ...And we needed another person and Valda was someone who we all had worked with at some point or other."[39]

John Rockwell, in an extensive article in the *New York Times*, announced the La Mama performances. To reassure the public of the seriousness of improvisational work, Rockwell discussed the preparation necessary:

> Preparation for Grand Union performances is a process aimed at "opening the senses, judgement, building trust," in Steve Paxton's words, and it has taken years to develop. ...The company won't simply rely on their past experience together. They will rehearse for two weekends and one weekday evening, working out improvisatory situations exactly as they would before an audience. "In reality," explains Mr. Gordon, "rehearsal is another performance, except there's nobody there but us."[40]

The fact was that the group needed the rehearsals in order to reestablish their timing and performance skills—Grand Union had not performed together since the Tokyo appearances four months earlier—and needed to integrate Setterfield into the group for this performance.

Judging from the reviews—the evenings at La Mama received unusually extensive coverage—these performances featured relatively less dancing and more wordplay. A typical sequence was described by Wendy Perron in the *Soho Weekly News* (6 May 1976): Gordon had got himself standing on a chair, slowly revolving as he told the story of himself as a bed-wetting adolescent who joined the circus. Deborah Jowitt, in the *Village Voice* (17 May 1976), gives another glimpse of the performance:

> The night I went to La Mama to see them, they didn't dance much, but were very bright and funny with words and ideas. Gordon danced Setterfield younger and younger until she ended up thumb-sucking. Lewis, bent on interviewing Dunn (who was dancing and curt) was herself being interviewed by Gordon who, he said, interviewed interviewers.

In a rather long article in the *Ballet Review*, Elizabeth Kendall expressed her overall disappointment with Grand Union: "'Light entertainment' does seem an accurate way to characterize the Grand Union's work in its present phase. The Grand Union are now playing pop versions, cartoons, of themselves."[41] Among Kendall's favorite moments was the closing sequence to one of the performances:

"The skit somehow crescendoed to an extravagant group procession, with Green carrying a crucifix, the others marching behind, and the Beatles wailing 'Let It Be' from the record player." But the company's struggle to integrate Setterfield troubled Kendall:

> One wondered why they decided to have her [perform], since she remained mostly peripheral when she wasn't duetting with David Gordon. ...Sometimes she attempted to join the two other women in some dance doodlings, but they barely acknowledged her. On the third evening, Setterfield performed an entire Royal Ballet "Sleeping Beauty" in a dim corner of the stage, miming all the parts—the Prince, Aurora, Carabosse, the mice—and no one on stage (except Gordon) seemed to notice. In the final performance, Dilley and Setterfield finally made peace—in a silent and breathtaking plastique duet of crawling, rolling gently turning over one another. It lasted to the edge of the long space, where they stood up and embraced.

The problems of incorporating a new member were addressed more sympathetically by Deborah Jowitt: "It must be tough, if exhilarating, to be a newcomer in one of those combustible Grand Union evenings." Jowitt mentioned missing Steve and Trisha, as one might miss family members at a gathering, and took the family metaphor one step further: "I felt an edge of sharpness and uneasiness during the evening which I couldn't quite trace. That happens in families too."[42]

Jowitt's perception of tensions between the performers—a hint of the troubles that were to come—was exactly on the mark. As Bruce Hoover explained, one source of tension came from Yvonne Rainer's indecision about whether to perform:

> There was a lot of discussion, before the last La Mama performance, about the possibility of Yvonne being in the performance. At one point, I saw the design of a brochure with Yvonne's name on it. It was going to be the last New York Grand Union performances, and how it evolved I don't know but Yvonne chickened out, so I'm told.[43]

66

Rainer did attend at least one of the La Mama performances, in the middle of which Barbara Dilley and Douglas Dunn had what Hoover called "a real altercation, not a fake altercation":

> It was real between Barbara and Douglas, about something Douglas had done or Barbara had said or both, and there was real anger going on, and it threatened to sort of take over. Yvonne stood up in the audience, and it was some discussion about some piece of art that Douglas had brought. Yvonne stood up, held her coat up and said something like "Is this a piece of art?" and David Gordon walked down to her and said, "You, you want to be in this? Fine. You don't want to be in it, then stay in the audience. Make up your mind." Yvonne sat down and the performance went on, but it broke the tension, oddly enough, and he was serious because he was mad that she wasn't there. I think that was the real issue. I think he had wanted her to perform.

David Gordon described the same incident:

> Yvonne clearly was very ambivalent about being there without getting up [to perform]. It had also happened at the Dance Gallery performances. She came to 14th Street and sat down and said, "I've come to watch" and it wasn't very long before she was up in the space and then offended by something somebody did to her. Pulled her pants down, something or other. She said it was an aggressive, hostile act. At La Mama she did the same thing. Said no, she wouldn't do the performances and then at some point appeared downstage near the door, that was my most airing-hostilities-time because I said, "Are you coming in or not? Because if you're not, got back and sit down and if you are, you can't get us all to stand here and focus attention on you and all the audience on you and not come in," and Yvonne said, "No, I'm going to go sit down" and I said, "Good, goodbye." It was hard for her I think, both to be in at some point and to be out.[44]

Reviewer Robb Baker describes the same evening's performance from an audience member's point of view:

Gordon also handled one tense moment, when an audience
member made an attempt to participate in an onstage action.
...with cool aplomb by snapping back, "Would you like to be
brought out here on stage or ignored?" But the real moment of
tension was between the Grand Union members themselves, on
the third night in the performance to which Dunn had brought
a painting to the theater and had hung it at one end of the
performing space. "This painting is by Deborah Friedman," he
announced about half-way through the evening. Gordon and
Setterfield immediately carried on a rubber mat and held it up
to the audience, stating, "This is a painting by Arnold Fried-
man," which elicited a good laugh. But when Gordon then
donned a serape and said, "This painting is by Jose Friedman,"
the ensuing laughter was a good deal more restrained. "I didn't
think we brought things to performance for the approval of other
people," said Dunn, and Dilley, trying to smooth things over,
joked, "It's getting a little competitive here, isn't it?" Gordon
quickly countered with, "What does that mean? You can't get
away with that stuff anymore," which seemed to bring past
tensions and under-the-surface hostilities into play. Things
worked themselves out in the repartee that followed.[45]

The resentments and hostilities so obvious at the La Mama performances
were nothing new. In a review of the performances at The Kitchen in 1974, Kathy
Duncan had already noted a "tell-tale tension developing between the performers"
(*Soho Weekly News* 13 June 1974), and the reviewer for *Dance Magazine* described
the following exchange:

Nancy goes into a hand-flailing solo, full of funky syncopation,
with a black floppy hat down over her eyes. She dances to a
kind of jazz she obviously feels more than I do, giving visual
expression—beautifully—to something that does nothing for me
sound-wise. Then without warning, David and Doug crawl into
the middle of her dance. Onlooker Barbara Dilley snaps out,
quite realistically, "You had to get in there didn't you? There
are fewer and fewer fine dances in this bullshit group." "I don't
think you should put down Grand Union in public like that,"
comments Trisha. "But they're telling lies," insists Barbara.

"There's no difference between my public and private lives, and they're telling lies. I'm fed up with it."[46]

In retrospect, some of the sources of tension between members of the company seem simple to identify. Each member of the company had a highly individualistic and strong personality; each had developed a particular style of movement; and each had preferences about the kind of dance movement deemed aesthetically acceptable in performance, the kind of music, and the weighting and balancing of the performance content among verbal, dancing, and theatrical elements. Over time, the differences in tastes became harder and harder to smooth over or ignore. Moreover, Grand Union's performance form encouraged head-on confrontations on stage. Anything could be said or done: indeed, the essence of their form and their appeal was the honesty and rawness generated by using real behavior as performance material. They also relied heavily on their offstage personal relationships as a source of creative material, further blurring lines between life and art.

During interviews in 1984 and 1985 individual members of Grand Union traced in detail the growing problems, animosity, and even open hostility that developed between various performers. Steve Paxton recalled all sorts of interpersonal conflicts, giving one example that concerned clashes of both personalities and performance styles:

> Barbara Dilley was quite angry for a year or more, maybe longer, with David Gordon because he was getting too powerful on stage. Now what do you do about that? She didn't like it that he could walk on and command and take over what was going on. He, meanwhile, was shy [by nature]...he is very shy and he works very hard at what he is doing...so his growing strength and assurance [on stage] was glorious for him and you can imagine, here was somebody really finding power on stage, time after time coming up with things and ways of being that for him were new freedoms. ...meanwhile Barbara is in a corner

bitching about exactly that. "David is so much freer than the
rest of us. He can't do that. He is using devices that are too
powerful."[47]

Some of the problems, Paxton felt, were endemic to working improvisationally as

a group: "In hindsight I tend to generalize and say this is what happens with

improvisation groups unless they get help or find the resources within [to resolve

interpersonal problems]." The eventual predictability and limits of improvisation,

he felt, inevitably brought about a frustrating sense of ennui:

> There are social and personal barriers in the form—organically
> there. Whereas at first you are fascinated by the freedom of
> movement of all the elements, after a while it seems rather
> predictable. In fact, they [the performers] are going on their
> own orbits and interacting pretty much the same way all the
> time, and you begin to realize that although the form has
> movement and dynamics of that movement might be unpredict-
> able, that the actual pathways and interactions start to be more
> and more predictable. You know by the look on David's face
> what manner he is going to be performing in for a while, and
> once again the adventure of the improvisation seems to be
> missing. It comes down to fairly intractable elements of
> personality that we either have to go into group therapy to deal
> with, and see what possibly we could have done, or else close....
> Maybe that's why we stopped—because the form, the
> deepest form, that was arising was the conflicts, the games that
> we all were involved in. You couldn't help have it be part of
> the show.

According to David Gordon, the interpersonal problems accelerated in 1975,

"when confrontation was occurring off the stage as well as on":

> I had an onstage confrontation with Barbara at La Mama in
> which I said, "You can't do that to me any more. Not in public
> and not in private. If you are going to say something negative
> about what I am doing and I question what it is you are saying,
> you can't back off and make lovey-dovey. I won't have it.

You're going to have to stand up and say what you're saying. We're going to have to fight it out." There had been other situations. There were other things like that, that had to do with each of us at various times in various places, and they never got sorted out and they just piled up.[48]

Gordon also recalled disputes over aesthetic elements:

One of the things we always did when we arrived in town, we went to the junkiest Salvation Army in town, found a whole batch of records for 10 cents a long-playing record. We did not know if they worked, if they didn't work, if they were scratched, whatever they were. We just sort of went through and picked eclectic junk.

And the day in Santa Barbara or Los Angeles or someplace, Douglas and I went. We found this batch of stuff, brought it over to the theater. We put it where the machinery was and used it during the performance. At the end of the performance Barbara was furious. "I will not listen to all that junk any more in performance. I want American composers." "Well Barbara, what are you angry about? All you had to do beforehand was say, 'I'd like to use *this* kind of music.' We could have said, 'No, you can't.' Or 'try' or 'we'll stop you' or...but you didn't say anything. How did we know that? We just did what we always do." "Well," Barbara said, "I think it's impossible that we are dealing always with this kind of European music and I think we should be using American music." "Great, Barbara, why don't you bring in what you want the next time?" And the next time was at La Mama. Barbara brought in "bloody" Keith, the pianist. That guy who plays hideous, eclectic smaltz, under the guise of it being improvisational. It sounds like tacky piano-bar music with art pretensions and that's what we had to listen to for practically a whole evening until I thought I would puke every time she put it on.

The Grand Union's members were in agreement that they did not want the performances to be public group encounters. But, according to David Gordon, few efforts were made to resolve personal or aesthetic problems in private:

You could not count on the fact that everybody would show, people who had said, "This is impossible. I can't deal with this anymore." If you waited for the ball to be picked up about something, it wouldn't happen. If I, who have a big mouth, then said, "Wait a minute. This is impossible. Something has to be done about it." The very person who would have said that to me, would say, "Oh, it's not so bad." ...Then I knew we were basically into a kind of avoidance. That continued into performance and that's how the work became eventually.

Barbara Dilley also pointed to the company's failure to develop methods for giving and receiving criticism:

It was quite difficult for us to achieve a proper way of critiquing the situation, and I think that was one of the reasons we couldn't continue. ...How to criticize and discuss and sharpen and tighten up our process was something that we didn't evolve along with it. There was some kind of mutual vision, but there was still a lot of isolation in the group, and it was not easy to critique one another. We didn't know how to give it, and we didn't know how to take it. There was a lot of vulnerability and I think toward the end that came up a lot more. There was more frustration. There was more criticism after performances.[49]

At an appearance in California in May 1976, Dilley felt full-force the misunderstandings that evolved from performances that hovered between the real and the make-believe:

David and I got into an extraordinary bit. I was an opera singer, and I was singing operatic-type material. I'd never done anything like that before. It just grew out of the intensity of the construction, and he nurtured and made this happen in many ways. I ended up going through this thing where he pushed this expression out of me and for some reason, I said to him on the stage, "I hate you" and we both left the stage, and I felt at the time that it was totally out of that expression that occurred on stage. I mean, I was not confused in my own mind, but he came to me afterwards in the dressing room. He said, "You

know I think you really mean that. I think you really hate me,"
and that got me very confused.

Also by this time two regular members of the group had left New York—
Barbara Dilley had moved to Colorado and Steve Paxton to Vermont—and the
company got together only to perform. In the absence of ongoing offstage contact,
the performers relied on old bits and familiar routines. David Gordon explained:

> I believe that as things became for us more predictable and less
> inventive and more fraught with personality difficulties, it
> became easier and easier to rely on that kind of material [comic
> routines, monologue]...and if we became crowd-pleasing at that
> point it was because there was no longer any time or any energy
> given to attempting to carry this work further in between
> performances. We barely met anymore in between perfor-
> mances. We met to perform, and when we met to perform we
> didn't know what anybody was thinking. We just went out and
> began doing the things we had already figured out how to do,
> except they came in different forms.[50]

The decision to disband came in the middle of Grand Union's most
financially rewarding year. The company had received its first grant from NEA,
for $10,000, and a grant from the New York State Council on the Arts. David
Gordon says, "We also knew full well that if we did well that year, we could apply
now [for a grant] and do it again next year. We also knew what nobody else
knew—including the NEA at the time they sent us the money. We were stopping
[working together] in Missoula, Montana."[51] On 10 May 1976, barely three weeks
after the last of the performances at La Mama, Grand Union gave its final
performance at the University of Montana.

NOTES TO CHAPTER IV

[1] Performance at the American Dance Marathon, ANTA Theater, New York; *New York Times* 17 May 1971.

[2] Steve Paxton, "The Grand Union," *The Drama Review* (Sept. 1971): 128.

[3] The benefits were held in January 1971; the loft performances are referred to in early reviews of the company and in interviews granted by company members. One series was held at a loft on 11th or 12th Street, six performances were staged at a loft on 14th Street, and another set at 112 Greene Street.

[4] Interview with Barbara Dilley, Nov. 1984.

[5] Deborah Jowitt, *Village Voice* 1 Apr. 1971.

[6] For 1971, Grand Union's management firm, Artservices, issued the following schedule of fees to potential sponsors:

full week east of the Mississippi	$7,000
half week east of the Mississippi	$3,500
full week west of the Mississippi	$8,000
half week west of the Mississippi	$4,000
single engagement	$2,500

[7] *Minneapolis Tribune* 29 May 1971.

[8] Interview with David Gordon, New York, Mar. 1985.

[9] Sally Banes, interview with David Gordon, Apr. 1975.

[10] Banes, interview with Gordon, Apr. 1975.

[11] Banes, interview with Gordon, Apr. 1975.

[12] Steven Koch, "Performance: A Conversation," *Art Forum* 11 (Dec. 1972): 56.

[13] Koch, "Performance" 56.

[14] Yvonne Rainer, "Engineering Calamity with Trisha Brown: An Interview," *Update, Dance/USA* (Oct. 1985): 22.

[15] The three performances were recorded on eight reels of videotape, but over time the second reel has disappeared.

[16] Robb Baker, *Dance Magazine* Aug. 1972; Don McDonagh, *New York Times* 30 May 1972.

[17] Robb Baker, "Grand Union: Taking a Chance on Dance," *Dance Magazine* (Oct. 1973) 41.

[18] Report issued by Artservices, "The Grand Union and Friends and Associates in Two Months of Performing and Carrying On," June 1973.

[19] Interview with Nancy Green, New York, Nov. 1984.

[20] Interview with David Gordon, Mar. 1985.

[21] Interview with Douglas Dunn, Apr. 1975.

[22] Banes, interview with Gordon, Apr. 1975.

[23] Baker, "New Dance," *Dance Magazine* Aug. 1974: 70–72.

[24] Baker, "New Dance."

[25] Baker, "New Dance."

[26] Banes, interview with Gordon, Apr. 1975.

[27] *Sentinel* (Montgomery County, Maryland) 28 Aug. 1974.

[28] *Washington Post* 23 Aug. 1974.

[29] Transcript of meeting between Grand Union and a group of dance critics, Oct. 1974.

[30] Transcript of meeting between Grand Union and a group of dance critics, Oct. 1974.

[31] Interview with Bruce Hoover, New York, Mar. 1985.

[32] *Village Voice* 31 Mar. 1975.

[33] *Village Voice*, 31 Mar. 1975.

[34] *Minnesota Daily*, 17 Oct. 1975.

[35] *Minneapolis Tribune* 7 Oct. 1975.

[36] *Minnesota Daily* 17 Oct. 1975.

[37] Interview with Hoover, Mar. 1985.

[38] Interview with Hoover, Mar. 1985. Elizabeth Kendall describes a similar chain of solos at the performance on 25 Apr. 1976 at La Mama Annex: "The last performance became an olio of Grand Union vignettes" (*Ballet Review*, the Grand Union, 53).

[39] Interview with Dunn, Nov. 1983.

[40] *New York Times* 18 Apr. 1976.

[41] Elizabeth Kendall, "Grand Union: Our Gang," *Ballet Review* 5.4 (1975–1976): 44–55; passages cited are from 50, 45, and 53.

[42] *Village Voice* 17 May 1976.

[43] Interview with Hoover, Mar. 1985.

[44] Interview with Gordon, Mar. 1985.

[45] Robb Baker, "Mary Hartman, Mary Hartman," *Dance Magazine* Aug. 1976: 22.

[46] "New Dance," *Dance Magazine* Aug. 1974: 72.

76

[47] Interview with Steve Paxton, Dec. 1984.

[48] Interview with Gordon, Mar. 1985.

[49] Interview with Dilley, Nov. 1984.

[50] Interview with Gordon, Mar. 1985.

[51] Interview with Gordon, Mar. 1985.

CHAPTER V

SYNERGY AND ENTROPY

The members of Grand Union were a diverse lot, but similar threads ran through the course of their early dance training and professional careers. Curiously, most had not had dance training as children. In the late 1950s, though, almost all of them—Steve Paxton, Yvonne Rainer, Trisha Brown, Nancy Green, David Gordon, Barbara Dilley, and Becky Arnold—took part in the summer dance programs offered at Connecticut College. There they studied with Merce Cunningham, Jose Limon, Martha Graham, and other dance faculty. Subsequently, many of these young dancers chose to continue their study with Cunningham in New York, and Douglas Dunn (who did not attend the Connecticut Summer Program), Steve Paxton, and Barbara Dilley later performed as members of the Cunningham company. Five of the Grand Union members also shared a common background as choreographers and performers in the Judson Dance Theater: Yvonne Rainer, Steve Paxton, David Gordon, Barbara Dilley, and Trisha Brown.

Despite their common professional experiences and influences, the strength of each member's personality and personal presence was as important to the company's success as their shared ideals and interest in breaking new artistic ground. Though the members disliked it when a reviewer singled out individual performers and identified their particular styles of performance, rather than focus on the ensemble effort, the company did recognize that each member brought a special area of expertise to the group endeavor and that the ensemble performance—

though more than the sum of its parts—was greatly affected by each performer's abilities and liabilities. As David Gordon explained it:

> So this "wacky something"—which the Grand Union came to be personified by—was very frequently a kind of thread that ran through the performance [while] people did their own individual, stylistic stuff, the stuff that they have later become identified with.[1]

Dancer Mary Overlie,[2] who attended most of Grand Union's New York performances, looks back at Grand Union as a union in name only:

> I think the work was totally based on the individual's artistic voice and challenges. There was no "we" dance, "we" talk, "we" think this. There was no "we" at all [except] at the moment of performance, they constituted a "we" because they all showed up.[3]

For one reviewer, the appeal of Grand Union resulted from the complementary strengths of the individual personalities: "Like the loyal audiences of traditional Eastern opera, we have come to know each character well: they are varying degrees of real-unreal for us; and we each have our favorites."[4] Another reviewer, noting the same strengths, focused on the interaction of personalities:

> What holds one to the group, and perhaps what holds the group together, is the definition and interplay of personality. More than any other group, the Grand Union banks on a cult of personality. ...Their appeal is similar to that of the Beatles; it's possible to like them without giving a hoot for what they do.[5]

It was true. Audiences were fascinated by the synergy among these highly skilled artists, the performance personalities they developed, the real-life personal material they brought to the work, as well as their individual and diverse abilities as dancers.

Yvonne Rainer

Yvonne Rainer was born in San Francisco in 1934 and came to New York in 1956 to study acting. She began to attend dance classes only because a friend was going:

> At the very first class I had a ball. I was always very athletic, and I didn't immediately want to be a dancer. I didn't know any professional dancers. I became very disaffected from acting. ...I went to Edith Stephen for six months, and then to various people on the periphery of the dance world. At a certain point, I realized I was pretty old...and I went to three classes a day for a year. Went in the morning to the Graham school, in the afternoon to ballet class, and in the evening to the Graham school again. In between I was going to every concert and every movie, and that year was my education...that was 1959–1960, so I was twenty-five.[6]

A late starter, Rainer quickly made up for lost time, studying with Martha Graham, and later Merce Cunningham. She studied ballet with Mia Slavenska and modern with James Waring and Peter Saul. She took composition classes from Robert Dunn, and attended Anna Halprin's summer workshop in 1960. In 1962 Rainer and Steve Paxton started the workshop that led to the formation of Judson Dance Theater.

As a performer, Rainer was strong and assertive, not controlling but certainly initiating episodes and giving overall direction to the work. Before Grand Union performances she would sometimes propose situations and ideas to try. She once got Barbara Dilley, for example, to agree to stage a physical fight. At a certain point in the performance, they each took a strip of foam rubber into the center. Rainer pushed Dilley in a mock-aggressive fashion. Soon they were wrestling, grunting, pulling, rolling, tugging at the mat and at each other's limbs and clothing. Nancy Green joined in.

The wide range of Rainer's performance style is nicely described by Sally Sommer, referring to a 1972 performance at the Lo Giudice Gallery:

> Yvonne walked around the space with that kind of sensuous torso movement-thing that she does....
>
> Yvonne came up with this little paper airplane. She'd put it in her mouth and she was laughing. ...Yvonne allowed the paper to stick to her bottom lip and would sort of flap it around.
>
> Barbara and Yvonne started doing one of those..."jazzy things," but it was very lyrical and lovely and soft...a kind of smooth flowing....
>
> The poses used in the performance, particularly the ones involving a pistol, have an archetypal/mythic feeling. They are a kind of vocabulary of gesture and "hold" that Rainer is presently working with...very powerful images. The next evening, Yvonne and Doug again did long poses using a sword. I think they [the poses] hook up with the American penchant for violence.[7]

Mary Overlie's impression of Rainer is that of a performer who arrived with certain ideas that she wanted to explore and had the ability to transform and insert these ideas into the material improvised by the group. Rainer's leadership qualities were often reflected, if subtly, within the ensemble work. Her choice of material tended toward pedestrian, gestural, verbal—and the totally outrageous. A favorite device of Rainer's was to read selected passages from a book into a microphone. Most of this material was tongue in cheek and often involved the other performers in some kind of ridiculous melodrama. The first time Overlie saw Rainer perform, she recalls, "I was so taken by her performance presence and the power of just reading from a book that I said to myself, 'Oh, my God, I have to follow this woman wherever she goes.'"[8]

But Rainer admitted that she felt ill at ease once Grand Union turned to totally open improvisation:

> I never did much in Grand Union performances. From the time that my material was let go of, I was never comfortable with the Grand Union. I'm not a good improviser. I don't easily get involved in these interactions, especially talking. I got involved in solo movement things, or movement with Steve [Paxton].[9]

Thus despite the power of her stage presence and the sinuousness of her brilliantly inventive mind, Rainer left Grand Union in May 1972, curtailed her dancing career, and eventually dedicated herself full-time to filmmaking.

David Gordon

David Gordon, like Rainer, did not study dance as a child. But at Brooklyn College he majored in fine arts, took dance classes, and choreographed his first work. Later, he performed with James Waring, and in 1959 Gordon went to Connecticut College for the summer, where he studied technique with Graham and Cunningham and composition with Louis Horst, composer for Martha Graham. On his return to New York, he began choreographing for Waring's composition class, and in 1962 he choreographed a variety of new works for the Judson Dance Theater: "My first improvisational and my first drag pieces came during that period."[10] Gordon regularly contributed works to the Judson concerts, some in collaboration with his wife, Valda Setterfield, up through 1966, when a painfully negative review brought him to a halt. That same year he began performing with Yvonne Rainer, and he continued to work with her as the concept of Grand Union was developing.

Gordon was not grounded in a strong modern dance movement technique, and at times he became self-conscious if pushed by the situation into a pure dance

sequence. In Grand Union, Gordon's performance style and persona developed, in an assertive, verbal, and primarily humorous direction. He would often devise a striking image, enhanced by an elaborate costume and the setting up of a theatrical situation. Nancy Green recalled the effect Gordon made: "His costumes were absolutely incredible. He didn't have to say anything or do anything after he'd made up in the dressing room. He was just total "character presence," and such a marvelous presence."[11]

One source of Gordon's imagery was Hollywood films, especially the movies of the 1940s. At an earlier Judson concert he had presented his *Garlandiana* (1963): "Gordon in top hat and tails stood in the space, smiled at the audience, kicked his foot shyly at the floor, and shrugged his shoulders for the duration of 'Somewhere Over the Rainbow.'"[12]

Gordon also liked to talk a good deal in performance, and Douglas Dunn recalled how Gordon would often announce a context or premise for an ongoing action: "He always seemed to be the one who tried to designate who we were. In that situation we became theater characters."[13] And as Gordon says, "I was always interested in theatrics. I wanted to use mundane means to a magical end."[14]

In an interview conducted in 1975, Gordon identified his candor and wit as one of his chief contributions to Grand Union:

> I think I was the first person in Grand Union to start being frank. I began to realize there was an opening for my wit and I'd been hiding my wit for years, and working with Yvonne it was non-existent. ...and suddenly here was an opening, I began to use it.[15]

In retrospect he called his time with Grand Union "both thoughtful and thoughtless":

> As I began to discover that an enormous amount of anything I could ever fantasize could happen on the stage, *for* me and *to*

me, and some things I never dreamed about, I began to actively fantasize Grand Union performances. It just seemed to me like the biggest, longest party I'd ever been to, and I had no idea when it all began that it was anything more than one of the most interesting stage experiences I'd ever had.[16]

Gordon traces his evolution as a verbal dancer to Trisha Brown, who encouraged him to explore his talent with words:

In a relatively thoughtless way, very flattered that Trisha thought that I had anything of interest to contribute to the situation, I began to respond. In the beginning I was performing for Trisha. "Let's amuse Trisha" was what I did. ...I didn't know how to turn off the faucet, my mouth, and what's more I began to find out that—not only did I have all this stuff to babble about—but that I was funny and people laughed. That sound of laughter was, in terms of a dancing life, the first audible, obvious approval I had ever understood, and it was great that I could hear this. I could say, "blah, blah, blah" and they [the audience] would go "hah, hah, hah," and it was great, and so I kept pushing that material forward.[17]

Gordon also began to develop performance material based on his role as intermediary between the audience and the performers. With microphone in hand, he would become a commentator, a disk jockey, or a game-show host, often involving the other members of the company in the game. His skill at generating quick-witted, humorous remarks and patter made him a favorite with audiences and critics. "Memorable moments. ...David Gordon playing emcee in a rapidly burgeoning monster-virgin routine he has discovered ("and now ladies and gentlemen, the only known version in which a trio of virgins attacks a monster").[18] In 1975, a reviewer described Gordon as "the most endearing, especially when he plays at being endearing." "He's the one most likely to ask someone to speak from the heart and get away with it. His colleagues fondly suffer his ingeniousness; the audience loves it. David also gets away with being adverse to solo dancing."[19]

Although adverse to solos and best remembered for his comic inspirations and charismatic presence, Gordon did some stunning dancing. Of a performance at the Guthrie Theater in 1975, the reviewer for the *Minnesota Daily* wrote:

> There's some utterly beautiful dancing going on...Brown and Gordon begin the evening with a quiet, hip-rocking, lolling by side-stepping series of movements that are nothing more than shuffling quarter turns winding around the stage—small circles within a larger perambulation. Brown may move in close enough to rest against Gordon for a few turns or, at points, shy away several feet, but most of the time they're shoulder to almost touching shoulder.[20]

And Douglas Dunn called Gordon's duets with Steve Paxton "the best dancing I ever saw David do":

> It was something very special when David danced with Steve, when they would do a duet, although it didn't happen often. They usually danced next to each other, rather than interacting physically, and it was always just incredible to me how they danced.[21]

Barbara Lloyd Dilley

Barbara Lloyd Dilley began dancing at the age of twelve, and after high school she spent a summer of dance study at Jacob's Pillow. She attended Mt. Holyoke, graduated Phi Beta Kappa with an interdepartmental major in American culture. The following summer she attended Connecticut College and studied with Merce Cunningham, James Waring, Aileen Pasloff, Daniel Nagrin, and Helen Tamaris. From 1963 to 1968, Dilley was a member of the Cunningham company and also danced in many of the Judson concerts. She started working with Rainer in 1966 and appeared in Rainer's *The Mind Is a Muscle* and *Continuous Project—Altered Daily*.

Dilley began choreographing extensively in 1968, both in New York and at residencies in various colleges around the country. In 1972 she founded her own improvisational dance group, the National History of the American Dancer: Lesser Known Species, Volume IV, Chapters 12–24. This six-woman company performed during the same time period as the Grand Union—although the improvisatory approach and concerns were very different. Dilley's work has always reflected her interests in Jungian psychology, meditation, and the Sufi legends and philosophy taught by Idries Shah.

More comfortable dancing than talking, Dilley only gradually developed her verbal abilities in performance. She was willing and had the versatility to work easily with all the other members, supporting their ideas whether in movement or theatrical terms. One reviewer said: "Barbara Dilley is the most versatile performer as well as the most volatile. She's a good interloper and keeps her colleagues awake."[22] Another reviewer noted her shy bravado, "Dilley also likes physical things, and seems slightly self-conscious about taking an acting role. But she'll fall in with any risky plan."[23]

Mary Overlie commented on Dilley's development as a performer:

> Barbara would dance. [She would] make up phrases and repetitions, but her role [gradually] changed. In the beginning she was [primarily] involved in unifying what was going on. She would get involved with other people's interactions. Later on she started establishing more of her own territory.[24]

David Gordon recalled:

> Through all the performances, from the very beginning, Barbara would ninety percent of the time do one of those kind of mythic, mystic dance events of hers with "schmatas" tied around her head and rings on her toes and all of that stuff. ...[or] in some situations [she would] set up some improvisational structure that she worked on.[25]

A review from the *Soho Weekly News* supports Gordon's view:

> Barbara Dilley is small and soft, wears comfortable clothes that
> let her comfortable body extend and curl and twine. She is
> patient and well grounded in manner and motion. She usually
> avoids verbal content, and when pressed, responds somewhat too
> earnestly. "A leader is someone who has wisdom," she informs
> David Gordon.[26]

Elizabeth Kendall, in an article in *Ballet Review*, gives a fuller account of
Dilley's contribution to the Grand Union performances:

> Dilley has performed the arts of gibberish, whistling, and
> clapping, and employs them lavishly to Grand Union ends.
> ...[also]... This season...[she] was the moralizer who sternly
> checked for hypocrisy.
> What she has, and can't get rid of, is the performing
> dancer's gift: her imagination works visibly through her body.
> When she strikes a pose, it has mysterious implications; it is
> charged. Dilley's dancing, even when she is just dance—fidget-
> ing, is rich in multiple planes and circles of space, the fullest
> dancing in the group. ...Dilley's serpentine arms, her dips and
> bends and light-footed little prances carry a sort of magic we
> think we have seen on other stages—she seems Fokinesque.
> When she takes it into her head to play a Svengali or a monster,
> she brings forth a dramatic force hitherto obscured, and any skit
> she is in coalesces around her.[27]

Yet Kendall also took Dilley to task for the way in which her moral and social
commitment could appear as mere moralizing:

> Dilley drains the life out of performances more often than she
> juices them up. If there is a lull, she steps in to introduce
> discussion or pose some soul-searching questions. "Do you
> seek embarrassing relationships?" she asks Douglas Dunn
> passing downstage of her. Dilley reminds me of Katharine
> Hepburn in her forties movies—another self-appointed con-
> science. ...At its worst moments, the Grand Union is like
> Barbara Dilley's Sunday School.

Nonetheless, Kendall concludes her remarks about Dilley by emphasizing her "projected radiance":

> Barbara Dilley wound up the evening by sitting down and reading a legend, "The Singing Stone," from a book about the Plains Indians, the story of a young girl's symbolic journey into adulthood. She read it in a lovely sing-song voice which hypnotized the audience and performers into quiet. ...I felt then that Barbara Dilley was peacefully projecting her keenest powers.[28]

Barbara Dilley's serious, idealistic outlook on life was an on-going influence on Grand Union. She was known to question out loud and sometimes even in performance the content of the members' work. A brilliant dancer, Dilley over time developed her verbal and theatrical skills to an equally sophisticated level.

Steve Paxton

Steve Paxton was raised in Tucson, Arizona, and studied Graham technique with local dance teachers. Deciding early to seek a career as a dancer, he set off for New York City after graduating from high school. In New York, he began classes with Jose Limon and Merce Cunningham and performed with both companies, with Cunningham from 1961 to 1964. In Robert Dunn's composition classes, Paxton began to create his own dances, experimenting with chance methods, picture scores, nudity, props such as plastic inflatables, videotape and film, and outdoor and nonproscenium environments. During this period, Paxton worked extensively with nondancers of "various shapes and sizes" and even went so far as to bring animals on stage.

A passion for exploring new ways of moving and methods for creating new work has remained strong throughout his career. "Paxton takes the most extreme liberated positions," Jill Johnston once said.[29] Paxton's intellectual curiosity, his

innovative and startling approaches, and his questioning of all traditional forms has led him to what Don McDonagh describes as, "his own musing search for the root of theater dance."[30]

Paxton and Yvonne Rainer were the principal organizers and contributors to the Judson Dance Theater. During these years, Paxton also produced a great number of dance pieces, solos and group works, collaborating with dancer friends such as Rainer, Deborah Hay, Trisha Brown, and Simone Forti. A member of the group of dancers that performed Rainer's *Continuous Project—Altered Daily*, Paxton played a key role in the evolutionary process that led to the establishment of the Grand Union. As mentioned earlier, from movement ideas and explorations growing out of the Grand Union performances, Paxton later developed the athletic duet form of improvisation called Contact Improvisation.

At the time Grand Union was founded, Paxton was already an established performer and a respected creator of a large body of dance work. Despite his natural modesty and his egalitarian philosophy, he stood out in the group. Mary Overlie says:

> I always thought that Steve brought in the artistic vision. He was the person to set the intellectual tone of the evening, and a lot of the stuff that he did was very intellectual and art oriented. He had a dance performance idea that was a concept, and the people played off of [this concept]. ...I think a lot of [Grand Union members] played off him because he was so available in the performances.[31]

Marcia Siegel, in her review of the La Mama performances in 1975, labeled Paxton "the conscience of the group, and also a subliminal prime mover":

> Paxton often seems to stay outside the jollier games, joining up with participants after they've finished, to talk things over confidentially—except what he's talking about might be some totally different subject—movie soundtracks for instance. There's a very strong drive for domination in Paxton which

seems short-circuited a lot of the time. It bursts out in li
carrying/throwing duets with Douglas Dunn, in his d
conducting of Nancy Lewis [Green] and the group i
interminable song without a tune.[32]

A *Village Voice* review briefly describes a Paxton moment: "Paxton lets a
sequence of somersaults build into a very interesting dance of quiet, deliberate arm
gestures (mostly). He looks kind of pondering and far-seeing."[33] Mary Overlie
was intrigued by what she called "Steve's nonmovement": "He would just stand or
lie down, which was definitely, for him, a dialogue with movement."[34] Paxton
himself, when reminiscing about the various styles and modes of movement he
explored within the Grand Union, recalls "dancing quite fully and with other
people":

> Also, I was very interested in weight and movement, and what
> I came to term as "instant by instant" movement. Just let the
> momentum take you places. I was working on a movement
> style and one that I still play [with] a lot. It is sort of like the
> solo version [of contact improvisation].[35]

In contrast to David Gordon's aggressive, impulsive, verbal style, Paxton's work
more often came from the ideas he brought to the performance for exploration.
Overall he contributed his extraordinary ability as a dancer, a steady sensitive
presence, an artistic vision and a wildly inventive mind.

Douglas Dunn

Douglas Dunn was born and raised in California. Like many other Grand
Union members, he did not have dance training as a child, but was active in sports.
At Princeton University he majored in Art History and started taking ballet classes.
After graduation he spent three years teaching in a prep school. Only then did he
decide to move to New York for serious dance study. He took classes with Merce

Cunningham and later became a member of the company (1970 to 1973). Though not a participant in the Judson work, he began working with Yvonne Rainer in 1968 and performed in *Continuous Project—Altered Daily*. In 1971 he began his own choreographic work.

At the time Grand Union coalesced, Dunn was the youngest member and the least experienced. Less entrenched in the conventions of the New York dance scene, Dunn had fewer preconceptions about dance:

> I was so fresh to the scene, the dance world, and so many of the things that apparently were radical about Yvonne's work and Grand Union were not radical to me. They were perfectly normal [to me] because they were so close to the kind of daily physicality that I knew from athletics.
>
> My own participation relied on [keeping up] my confidence so I wasn't really open to the kind of critical attitude toward the work that some [other] members had. I danced a lot with Barbara [Dilley] and Nancy [Green]. I was able to do certain kinds of dancing with Steve, certain kinds with David and only occasionally with Trish.[36]

Whether because of his age or newcomer status, Dunn did not have an ongoing offstage relationship with the other members of the group. As Mary Overlie saw it:

> [Dunn] didn't have the personal dialogue going with the others. ...I think that he was always slightly uncomfortable. It was a strain for him until four or five years later, until he could dominate an area for himself, and people were more appreciative of his presence there, not that they weren't from the beginning.[37]

For Dunn, it was a time to experiment with different dance vocabularies:

> Since I was training myself to dance during those years, I had very weird—[in] the context—dance impulses. Sometimes I wanted to try out classical vocabularies, beats, etc. I liked to dance much more than I liked to talk in the performances, and

> I liked to dance as much by myself as with the others, and I got
> on dancing better with some than with others because of their
> personal dance [style].[38]

The reviewers consistently noted his preference for solo work: "[Dunn] prefers to dance by himself, and the group easily tolerates his lone-wolfishness. Besides, Doug's solos are useful; when a group activity is falling to pieces, one can usually rely on him to be doing something interesting in his corner."[39] "Brown and Dunn seem to like working on movement ideas, alone or with others, better than they like skits. ...Dunn did a long solo standing still, moving only his mouth—later he added the eyebrows."[40]

Dunn recalled working to develop a performance character that was an "ambiguous dance figure, not easily identifiable."[41] But the reviewers did identify him. Elizabeth Kendall, critiquing the 1976 La Mama performance series, noted: "Douglas Dunn [and Valda Setterfield], throughout most of these evenings, were the dummies. They generally spoke only when spoken to: Dunn likes to play the loner (stalking in the shadows and wearing low-brimmed hats)."[42] And from another reviewer's observations of the same series:

> Douglas Dunn is lean and angular, with a determined look on
> his face. The black clothes and hat he wore on Sunday night
> made him look preacher-like, and he played into that by striking
> stark poses. The intention of his dancing is very evident, and
> he likes to channel this clarity into weight studies—lifting,
> catching, yielding to, testing another's weight.[43]

But Dunn also had his outrageous moments. Bruce Hoover recalls a performance at the University of California, Los Angeles, when mid-concert Dunn sidled over to ask Hoover to wait about two minutes and then bring up a spotlight in the far upstage corner. When Hoover brought up the spotlight, there was Dunn—completely wrapped, including headdress, in aluminum foil. The reviewer from the *Los Angeles Times* caught the moment:

Through all this, Douglas Dunn had been dragging on props and assorted equipment, calling for light cues, playing with an opaque projector and taking snapshots with his polaroid. All very offhand. ("It's really nice to come to the theater and have a little peace and quiet, isn't it?") But eventually he too succumbed to the theatrical impulse, shedding most of his clothes and dancing his aluminum foil Tin Woodsman costume to tatters with his stage-sweeping runs and forceful, off-center spins.[44]

Trisha Brown

Trisha Brown grew up in the state of Washington. As a child, she studied dance—the usual dance-school melange of ballet, tap, jazz, and acrobatics—and was very active in athletics. Brown completed a dance major at Mills College and attended the summer programs at Connecticut College, where she worked with Jose Limon, Louis Horst, and Merce Cunningham. In 1958 she began teaching at Reed College: "I stayed there two years, but exhausted conventional teaching methods after the first few months and then became involved with improvisational teaching."[45]

In the summer of 1959, she attended Anna Halprin's summer dance workshop in San Francisco, where she met Yvonne Rainer and Simone Forti. Halprin's improvisational work introduced Brown to new compositional concepts based on tasks, randomness, and games. As earlier mentioned, while working with Halprin, Brown explored such ordinary tasks as "sweeping up": physical task movement ideas within an improvisational format. "There was also experimentation with sound—verbalization and singing as material—and beyond that, defined or wide open improvisations night and day by very talented people."[46]

The following fall, Brown moved to New York and began working with Simone Forti and Dick Levine on improvisational dance problems. Brown explains the difference between open improvisation and structured improvisation by reference to jazz:

> If you just turn the lights out and go gah gah in circles, that would be therapy or catharsis or your happy hour, but if in the beginning you set a structure and decide to deal with X, Y, and Z materials in a certain way, nail it down even further and say you can only walk forward, you cannot use your voice or you have to do 195 gestures before you hit the wall at the other end of the room, that is an improvisation within set boundaries. That is the principle, for example, behind jazz. The musicians may improvise but they have a limitation in the structure just as improvisation in dance does. That is what I would call structured improvisation.[47]

Within the structured improvisation form, group dances involve not only the individual's own space-and-time framework, but also that of the other dancers. Or, as critic Sally Sommer says, "The dancer is caught inside a system, a structure—and movement arbitrates between performer and the structural rules."[48] The rules may be as simple as theme and variations, but in more complex forms they may involve environmental concerns, the manipulation of props, even mathematical concepts.

As Brown continued her early choreographic explorations with structured improvisation, she also attended Robert Dunn's composition class. In 1962 the first piece she performed at the Judson was a dance based on movement rules: She could only sit, stand, or lie down. In a later example of Brown's use of structured improvisation, the duet *Target* (1964), vigorous choreographed dance phrases were cued by the performers extemporaneously asking questions like "What time is it?" or "Where are we?" Each question prompted an abrupt, spontaneous change to a new dance section. Although a "feeling tone" or particularly expressive qualities

arose in this kind of work, the performers' primary intention was to spontaneously select movements that fulfilled their own artistic vision while complying with the rules of the system. The expression of emotional content or feelings was an incidental outcome.

During the 1960s Brown continued to establish herself as a respected dance choreographer in New York, and she was deeply committed to her own individual, avant-garde work. In 1968 she presented the first of her unusual "equipment pieces," in which external support systems aided the dancer in climbing walls and other gravity-defying feats. In 1971 she presented an evening of equipment pieces at the Whitney Museum.

Although Brown was not among the original cast of Yvonne Rainer's *Continuous Project—Altered Daily*, she appeared in Rainer's *War* at Rutgers University in 1970. Impressed by her talent and experience, David Gordon campaigned hard to recruit Brown into Grand Union. In 1975 he recalled:

> Trisha was dynamite. I am the one who absolutely pushed for getting Trisha into Grand Union. She was invited and very hesitant and uncomfortable about a possible conflict or confusion about her own career and her career in the Grand Union, especially about her relationship with Yvonne in that situation— Yvonne being the heaviest name. I said, "Promise her anything. Get her into this situation. Whatever she wants...put her name first, tell everybody it's all her idea. Do *anything* to get her into the situation."[49]

Brown did join, but her initial reticence persisted, and as Douglas Dunn remembered it, her ambivalence about Grand Union continued:

> First of all, Trisha, I think, was there and not there as part of the group. I think of her as someone who was not quite clear whether this was okay to be doing. ...She was the one who most questioned how we did things...and wanted to discuss afterward why we couldn't make it better.[50]

Barbara Dilley attributed Brown's intermittent dissatisfaction with the group to both personal and professional factors:

> She was invited in, and so she didn't have as much investment [in the group], and she had [had] a completely different training. She had a lot more improvisational training. She's a very independent lady, very personally involved in her own process, and in some ways I think it [Grand Union] really bored her... because it was extremely familiar work...she [would] just as soon get on with it on her own terms, in her own way. She pretty much always knew what she wanted to do.[51]

There was never any question, however, that Brown's contributions to Grand Union were highly regarded by the members. Barbara Dilley remembers Brown's verbal materials as outrageously funny, and Steve Paxton described briefly some of the strong characteristics that made Brown a great collaborator:

> Trisha might be soap opera, or she might be anywhere. You couldn't tell from the expression on her face. She is very bright, and she also plays her cards cagily, and so there was an element of surprise with her. ...[She] was unpredictable, spontaneous to work with and provocative.[52]

Mary Overlie emphasized Brown's conceptual contributions:

> Trisha danced task-oriented, very beautiful movement-systems dances and sometimes Trisha worked in concepts, usually unit concepts, small movement concepts. [Paxton and Brown] would make a bridge sometimes [linking performance episodes] which was very exciting.[53]

And a reviewer commented: "In her unassuming way, Trisha is the most aggressive and analytical of the group. She is usually the prime mover and the one best able to step out of the action and rearrange it, and sometimes stop it."[54]

By her own account, Brown's contribution to Grand Union often involved her constructing and performing small structured pieces that were being disrupted

and interrupted continually—at times to her great dismay. She remained committed to Grand Union, but felt stymied by the group's process; in 1973 she explained her growing disillusionment with the company:

> I wouldn't desert them, as I wouldn't desert a member of my family or close friends—but I'd like to, half the time. It's a mess. With a gang of people you function at the lowest common denominator, which is my complaint about the Grand Union. It functions at the lowest level.[55]

Meanwhile her own work was making more demands on her time.

By the end of 1975, Brown had decided to quit Grand Union. She did not participate in the California tour or the last performance at La Mama. She says: "I left the Grand Union in 1976 to address full attention to my own choreography, after many months of discomfort at not being able to edit or control the contents of a Grand Union concert."[56] In discussing Brown's final months with the company, David Gordon remarked on the odds she faced in trying to bring the others around:

> If there were people who tried to influence further change, it was basically Steve and Trisha. Steve, being the passive guru, could not aggressively make that happen, and Trisha...would complain about certain decisions or that things were difficult, but she would not or could not do battle.[57]

Nancy Lewis Green

Nancy Lewis Green's childhood was spent in New Jersey, California, and Rhode Island. In the summer of 1958 she attended Merce Cunningham's class at Connecticut College, where she met Barbara Dilley and Steve Paxton. That fall, she moved to New York City, where she continued her classes with Cunningham until 1970. She also studied dance with Jose Limon at the Juilliard School. As Green describes it, every time Cunningham was about to ask her into his company

she got pregnant. (Green has three children.) However, she did perform with Lucas Hoving, Anna Sokolow, Jack Moore, Twyla Tharp, and Jose Limon.

Green was not an established choreographer when she joined the Grand Union in 1970. At that time, David Gordon explained, the company had no system for auditioning new members:

> What happened was that people were bringing people into rehearsals. "So and so wants to work with us." ...We all considered it a democracy. How do you say no? And nobody ever said, "Well we'll try it, and if it doesn't work out, we'll ask them not to come back." So anybody who came, and the three people who came, Trisha Brown, Nancy Green, and Dong, were [accepted] in the Grand Union. [It was] very lucky no more people came.[58]

Though getting in may have been easy, performing improvisational ensemble work was not. Steve Paxton recalls some of Green's difficulties:

> She felt uncomfortable for years and years, and one of her modes of being uncomfortable was to sit on the stage doing nothing, or occasionally kind of querulously pulling that thing of "don't leave me"...a real plea but also sort of a cliche. She was one whom you had to accommodate constantly, and so sometimes David, for instance, would accommodate her to a degree that she could barely tolerate. Like, if she had nothing to do, he would chain her up, so she could do nothing—which put her into a dramatic version of what she in fact was into. All kinds of things were tried. We didn't [intend to] just abandon her, but sometimes we did.[59]

However, critics and audiences found Green's performance endearing. In a 1973 review, Don McDonagh admitted, "Personally, I would find an evening without David Gordon and Miss Green hard going."[60] Marcia Siegel was equally supportive of Green's performance:

> Nancy Lewis is a perfect foil. She plays the ingenue—the dumb, attractive female. ...Lewis is also the possessor of the

quickest imagination. She can become a sylph or a monster or a Grecian shepherdess just like that, can vocalize like a Moroccan at prayer. It was Lewis who saw the hilarious possibilities of all three women doing a hand dance with a follow spot, and Lewis who initiates episodes of sexual innuendo. Walking arm in arm with Dunn, she asked, "Is this your first time?" "Never you mind," he replied.[61]

And two reviews of a 1976 Grand Union performance at the La Mama Annex spotlighted Green's particular appeal: "Nancy Lewis is tall and goofy and, although she has been compared to Carol Burnett, I see more of Holly Woodlawn in her. It is fun to watch her mercurial changes between chic, sulky, and disarmingly sensual. She is a parody of herself."[62] "[Green danced] exceptionally well throughout the series. ...in her fluid, stream-of-(kooky)-consciousness style."[63]

Perhaps Bruce Hoover best described Green: "Nancy was a dizzy person. She played the 'dumb' female and perhaps it was a way for her to deal with the hard moments of a performance."[64] A reviewer agreed: "Nancy Lewis is the group's Marilyn Monroe, the smart dumb bunny."[65]

Becky Arnold and Dong

Becky Arnold and Dong (Lincoln Scott) were briefly members of Grand Union. Arnold had been part of the group that performed Rainer's *Continuous Project—Altered Daily*, and Dong joined Grand Union in 1970, at the same time as Trisha Brown and Nancy Green. According to its members of Grand Union, neither Arnold nor Dong had fit into the group particularly well or stayed very long. David Gordon comments:

> Dong left after a while at his own choosing. To me, he never seemed comfortable with the work we were doing, but we never discussed it with him. Becky had been uncomfortable from the beginning. ...I think she kept waiting for the moment Yvonne

would reassume authority, but it never came. In small groups, we discussed the difficulties we were having with some of the people, but it was impossible ever to sit down as a large group and work things out. Becky finally moved to Boston and relieved herself of [either] having to quit or come to terms with us and the work.[66]

Coming to terms with Grand Union was, finally, an extremely demanding physical, emotional, and artistic challenge. Each member had to be a strong and versatile performer, capable of joining someone else's physical world and supporting and advancing other's material. The risks and the exhilaration of meeting the demands of the moment, of interacting with the group provided the best and worst of times, said David Gordon:

The bravest times for me, personally, were those moments in performance when I would not take myself away at a moment when alien physical material began to develop, which is not to say necessarily dangerous physical material, just alien to me, my way of moving my body. When that kind of material started to develop, most frequently I found ways out, so that I didn't have to look physically foolish or inept, and very occasionally, I would absolutely persist or find myself in such a position in the middle of it I couldn't get out, and then I would do somebody else's physical world, and those moments I felt brave or foolish.[67]

NOTES TO CHAPTER V

[1] Interview with David Gordon, Mar. 1985.

[2] Overlie, a New York dancer, first saw Grand Union perform in 1971 at the San Francisco Art Institute. She followed the company to Oberlin College, where she worked with Rainer, and then on to New York, where she studied and performed with Barbara Dilley. Overlie was later invited to perform with Grand Union at a concert on Greene Street, but that was the only performance she did with them.

[3] Interview with Mary Overlie, May 1983.

[4] *Soho Weekly News* 6 May 1976.

[5] *The Nation* 12 Apr. 1975.

[6] Bear and Sharp, "An Interview with Yvonne Rainer" 53.

[7] Sally R. Sommer, audiotape transcription, 1972.

[8] Interview with Overlie, May 1983.

[9] Banes, *Terpsichore* 230.

[10] Gordon, quoted by Baker, "Grand Union" 42.

[11] Interview with Nancy Green, Nov. 1984.

[12] Amanda Smith, "Keeping the Options Open," *Dance Magazine*: 77.

[13] Interview with Douglas Dunn, Nov. 1983.

[14] Arlene Croce, "Profiles, Making Work," *The New Yorker* 29 Nov. 1982: 52.

[15] Banes, interview with Gordon, 1975.

[16] Interview with Gordon, Mar. 1985.

[17] Interview with Gordon, Mar. 1985.

[18] *Village Voice* 31 Mar. 1975.

[19] *The Nation* 12 Apr. 1975.

[20] *Minnesota Daily* 17 Oct. 1975.

[21] Interview with Dunn, Nov. 1983.

[22] *The Nation* 12 Apr. 1975.

[23] *Soho Weekly News* 27 Mar. 1975.

[24] Interview with Overlie, May 1983.

[25] Interview with Gordon, Mar. 1985.

[26] *Soho Weekly News* 6 May 1976.

[27] Kendall, "Grand Union," *Ballet Review* (1975–76): 51, 53.

[28] Kendall, "Grand Union" 53–54.

[29] Jill Johnston as quoted by Robb Baker, "Grand Union" 42.

[30] McDonagh, *Rise and Fall* 122.

[31] Interview with Overlie, May 1983.

[32] *Soho Weekly News* 27 Mar. 1975.

[33] *Village Voice* 24 May 1973.

[34] Interview with Overlie, May 1983.

[35] Interview with Paxton, Dec. 1985.

[36] Interview with Dunn, Nov. 1983.

[37] Interview with Overlie, May 1983.

[38] Interview with Dunn, Nov. 1983.

[39] *The Nation* 12 Apr. 1975.

[40] *Soho Weekly News* 27 Mar. 1975.

[41] Interview with Dunn, Nov. 1983.

[42] Kendall, "Our Gang" 51.

[43] *Soho Weekly News* 6 May 1976.

[44] *Los Angeles Times* 4 May 1976.

[45] Banes, *Terpsichore* 77.

[46] Anne Livet, ed., *Contemporary Dance* (New York: Abbeville) 44–45.

[47] Livet, *Contemporary Dance* 44–45.

[48] Sally R. Sommer, "Trisha Brown Making Dances," *Dance Scope* 11.2 (Spring/Summer 1977): 7.

[49] Banes, interview with Gordon, 1975.

[50] Interview with Dunn, Nov. 1983.

[51] Interview with Dilley, Nov. 1984.

[52] Interview with Paxton, Dec. 1984.

[53] Interview with Overlie, May 1983.

[54] *The Nation* 12 Apr. 1975.

[55] Banes, interview with Brown, 1973.

[56] Banes, *Terpsichore* 231.

[57] Interview with Gordon, Mar. 1985.

[58] Banes, interview with Gordon, 1975.

[59] Interview with Paxton, Dec. 1984.

[60] *New York Times* 3 Apr. 1973.

[61] *Soho Weekly News* 27 Mar. 1975.

[62] *Soho Weekly News* 6 May 1975.

[63] Robb Baker, "Mary Hartman, Mary Hartman" 21.

[64] Interview with Hoover, Mar. 1985.

[65] *The Nation* 12 Apr. 1975.

[66] Banes, *Terpsichore* 226.

[67] Interview with Gordon, Mar. 1985.

CHAPTER VI

OFFSTAGE

Follow No Leader

Initially, Grand Union operated under a nonauthoritarian, nonhierarchical ideal. But that meant that no one member could step forward to speak for the company or to make decisions about bookings, personnel, or the staging and the content of the performances. In 1973 Trisha Brown spoke of the frustration and confusion produced by group decision making:

> It's just a mess. Those arrangements where everybody has an equal voice. You never get anywhere. You sit around, and one member says "up" and three say "down," and there you sit for twenty-five years...there is no single ego that is taking care of the problem.[1]

Steve Paxton recalled with a laugh, "All of us did as little as possible at different times. People would take it [the management] on for a while, and soon get tired of it. Then somebody else would take it on, and it would flounder for a while."[2]

Within the first two years, however, Artservices, the New York arts management company that handled Yvonne Rainer's performances, began assisting Grand Union. Brown described the management support that Artservices supplied:

> It does take a lot of work to make sure the critics are there, the chairs are ordered. The underpinnings of any concert take work. Artservices takes care of us as much as they can. They are very generous to us in terms of how much they charge and how much they do. The series that we did at Dance Gallery

[1973],...Artservices donated one staff member who worked full time.[3]

Of course, even with Artservices' aid, many organizational issues had to be addressed by the company members, as Douglas Dunn pointed out:

> First, we had to decide whether we were going to accept a particular performance booking, which usually meant if we were available we went, because we wanted to perform. However, there was a period of time when we were spread out. Barbara [Dilley] was living in Boulder, and people had schedules. Their own work escalated in the mid-seventies, and it got more complicated. But strangely enough, usually when we had dates, we all managed to get there, and it was wonderful.[4]

At one point the company decided to delegate one member, called the "funnel," to act as Grand Union's conduit and liaison for matters relating to promoting the company and dealing with Artservices. As Bruce Hoover later recalled: "Nobody was boss, but there were alternating people who were the funnel. Nobody wanted the job, but it became a system of dealing with things."[5]

Once the company arrived at the space where they were to perform, decisions had to be made about lighting and sound. At some spaces, such as lofts or art galleries, there were few choices: "A big room with chairs around—like the Whitney Museum—we [just] turned the lights on."[6] Other decisions about staging were made intuitively as company members scouted the performance space. "There were no rules," Douglas Dunn noted:

> At times I could feel people holding back a little, so that others might have some input. But most of the decisions were made just the way we performed. That is to say, whoever speaks, speaks. Whoever dances, dances. Someone would just say, "Let's put the chairs over there." I don't remember a lot of arguing over these decisions.[7]

For the technical crews at theaters, though, Grand Union's easygoing approach to technical matters was sometimes quite trying. Dunn recounted:

> If the theater was not accustomed to dealing with a company that had no lighting person and no stage manager, sometimes we drove them crazy...the ones who couldn't relax and get involved in our process. For example, Barbara [Dilley] might say, "I need a red special." Then David [Gordon] would ask, "Could you light all from the side tonight?" So the theater technician who was responsible would start getting different inputs from different people, and sometimes contradictory [instructions]. ...Some liked it, and they could get into our process and work with us. ...But other times we got a minimal kind of cooperation.[8]

Nor during the early years did Grand Union have its own stage assistants. The performers themselves put the records on the turntable and took them off, or audibly requested that a fellow performer change the music. During the Lo Giudice Gallery Series in 1972, for example, at one point David Gordon yelled out, "Would someone please turn off the goddamn music!"[9]

The problems brought about by not having a stage manager to handle the technical aspects, particularly in larger theaters, were eventually solved by the hiring of Bruce Hoover in 1974, at the time of the summer performances at Lewiston State Art Park. Hoover describes why he was hired:

> I know this from several of them, that they had gone through very unhappy experiences, one in Philadelphia and also at Wolf Trap [Washington, D.C.] trying to make collective decisions before the performances about what the lights should be like. They didn't have anybody who traveled with them who could make that kind of interpretation or negotiate with the crew of the theater. Most of them are really not technically minded in the theater. They simply did not have the language to deal with stage hands and relatively sophisticated things like lighting switchboards. ...It's fine in a loft, but when you are dealing with a big theater with union stage hands and all kinds of

complications, you have to be able to say something ahead of time about what it is you might do.[10]

As stage manager, Hoover was entrusted with all negotiations with theater stagehands and crew, both before and during the performance. If a performer had questions or directions about the sound system, lighting, or scenic elements, Hoover was there to find the answers and relay the messages.

Stagecraft

Prior to the concert company members would start a "little performance" in order to acquaint themselves with the space. Douglas Dunn said: "This was the one time we would rehearse. We would start up and perhaps go for fifteen minutes. Maybe only four of us would want to do this, and it [the decision to do this] was always spontaneous."[11] Another performance ritual involved scrounging around for props and costumes, Bruce Hoover recalled:

> Most often when we'd go to a college for a residency situation, the members would go to the prop room of the theater department and find objects [to use in performance] prior to the performance. They wouldn't have anything in particular in mind, as to the use of this prop [or that]. They'd go in the costume room as well, and end up with parts of costumes that they could pull out of trunks and things. ...There was always a session before the performance about what was available in the theater to manipulate. Nothing was ever planned but rather [we worked with] what [was] possible.[12]

Hoover would also brief the performers on what lighting effects were possible, a report based on his independent scouting:

> I would go to the theater without them, having talked to people on the phone ahead of time. I set up a light plot which had, depending on the size of the stage and the number of instruments

that particular theater had, either nine, twelve or sixteen areas, or pools, one next to the other. I would put two or three lighting instruments in each of the pools. This allowed flexibility of having light all over the stage, or a path of light upstage or downstage or a path in the center.

The principle of using whatever was available in a theater applied to all manner of objects. Hoover remembered, for example, what happened when Steve Paxton became particularly interested in the light trees at the University of California, Los Angeles:

> There were light trees with casters on them in the wings, and Steve in that Grand Union fashion said, "Do those move?" I said "Yes, sure they move." So I went and negotiated all of this with the technical people there. Nobody [at the theater] was ever prepared for the kind of anarchy that was going on. In the end, I think there were four or six light booms, with lights all over them, and the lights were manipulated at the beginning [as part of the performance].

During performances Hoover usually stood at the side of the stage, in clear view of the audience. He would closely watch the performance, interpret signals from the performers, and, with the aid of an intercom system and headphones, give instructions to the theater's lighting technician and sound technician. If a performer said to Hoover, "Bring the light up in this area sort of slowly," he would translate that to the light technician as, "Bring up dimmers 5, 8, 9, 12, and 15 in a 20-count."

There was never a set system of signals between the performers and Hoover. Some members used various hand signals; others just walked over to Hoover and told him what they wanted next. Sometimes the signals weren't clear, but a casual attitude toward technical matters was fully consistent with the "spontaneous" factor of improvisation as a performance form:

Somebody would look at me and wave their hand a little bit.
Probably that meant, bring up the lights some more—or the
reverse. Nothing ever got codified, which was just fine with
me. Indeed there were occasions when somebody would make
a signal with their hands, and I'd do the opposite of what they
meant. Later, we would all laugh about it because they knew
I was trying to do what they wanted, but the communication
wasn't always clear.

Follow spots were particularly favored, Hoover explained, "because you can
improvise with them":

You can go anywhere on the stage, and as long as it's on you,
you are visible. If there's other light onstage, it will punch up
[accent] that particular thing. Sometimes people came over to
me and said, "Put a spotlight on him. That's really wonderful,
what he is doing." Or "Let's put a spotlight on that and take
the other stuff down a little bit because that's really extraor-
dinary."

As recollections like these indicate, Hoover himself did not make any major
decisions about lighting effects—those were made by the performers. He would
bring lights up or down on an area, follow the flow of activity, highlighting and
fading out areas as the performance evolved. One particular effective lighting plan,
he recalled, was suggested by Barbara Dilley before a performance at La Mama:

There's a section in one of the La Mama performances where
the lights very slowly go almost down to zero, in about twenty
counts. Not quite zero, you can still just see. Then in twenty
counts they come right back up again, and they kept doing this
for about ten minutes. Very slowly up and down. At the end
of the performance, Douglas said to me, "Bruce, that was really
brilliant, what you did. That was just wonderful." "Douglas,"
I said, "that was Barbara's idea. I had nothing to do with it."
She said, "I'd like the lights to come up and down slowly for a
while," and I said O.K., and that's how it evolved, and it really
was extraordinary.

The cues for music and sound effects were handled in a similar fashion, Hoover noted:

> Usually the soundman or soundwoman was sitting right next to me at a big table on one side of the stage. On the table were two turntables. Ideally, we always had to have two record players so that you could crossfade from one record to another.
> Somebody would walk over to me and say, "Oh, you see this cut here, Bruce? Just crossfade into that in a little while. I'll give you a signal." I'd say O.K., and I would do that. If the cut ran out, sometimes I would make a decision to take the music out if people weren't still dancing or if it didn't seem necessary. Sometimes I'd put something else on that was of interest to them.

The selection of music for the performance was random, unplanned, and totally up to the individual performers. Often the members of Grand Union brought records to the performance, but sometimes nobody brought any. During college residencies, dance departments' record collections were a source of music, but more successful were midday sorties into local thrift shops. There, for perhaps a quarter, one could buy a scratchy album, an outrageous piece of kitsch, or a bizarre sound-effects recording. Hoover, for example, recalled someone having found a bowling record. "The sound of bowling on a record...we played it." And Douglas Dunn reminisced: "Someone might just put on Beethoven's Fourth Symphony for no reason, except they brought the record at a secondhand store that afternoon, in a town we were in, because they saw it, and it was cheap, and it had the kind of scratches that they liked."[13]

For Steve Paxton, the eclectic assortment of music Grand Union used in performance was "a bit of rebellion" against the kind of music that had become fashionable in contemporary modern dance: "There was this Satie craze in the late sixties for instance, which followed a period when he was relatively obscure for dancers. The Grand Union was reacting against this kind of mind set, this

pretentious selection of composers."[14] The music for the 1972 performance series
at the Lo Giudice Gallery, for instance, included selections by popular rock groups
like the Rolling Stones and The Who, old blue records, country western vocals and
instrumentals, a recording by Edith Piaf, Cat Stevens' *Tea for the Tillerman*, a
Sonny Terry album, some Scott Joplin ragtime piano, music by Janis Joplin, Bob
Dylan, and Aretha Franklin, and the Grand Union singing "Somewhere Along the
Way." Bruce Hoover recalled a period when Barbara Dilley became interested in
the composer Terry Riley and brought in some of his piano music. Classical
records were often included, and once a member of Grand Union brought a
recording of *Swan Lake*.

The music not only accompanied the performance, but was one way of
controlling the performance, changing the direction of the action or the mood. As
Nancy Green described it:

> [the music] would very often bring us together and change the
> moment, change the scene, change the energy. You know like,
> next scene—scene two. ...It simplified all the intellectual, verbal
> stuff. It cleared the air, and you could dance a while and get
> into a physical self...and it would always make a grand finale.
> ...I recall our dancing to the Beatles. We were very much at the
> time of the Beatles. They had a new record coming out every
> other week.[15]

If the group seemed to particularly enjoy a musical selection or find it
inspiring, the piece would be used over and over again. Barbara Dilley:

> We had Ike and Tina Turner's "Mountain High and River
> Deep" piece for a while played [in] every performance. There
> were certain pieces of music that became totally identified with
> the group and would be put on at certain times. It's important
> to realize that there was quite a lot of repetition [in the music].
> There was Ringo Starr's "Hare Krishna" piece. We used to
> play it all the time. There was the famous Harry Nilsson
> record. That record was like a really powerful Grand Union

record. We used both sides of it and all of the songs a lot. It has "You've got to jump into the fire and put the lime in the coconut." There were just certain pieces of music that were like our muzak. Of course, people also brought in a little jazz, some ethnic, and it might last for only that once if it didn't go over. Then you didn't bring it back.[16]

Grand Union also explored vocal possibilities other than speaking or reading. They sang, hummed, spoke gibberish, and whistled. It soon became necessary to use microphones, which gave Bruce Hoover a new set of concerns:

We began to work with microphones for everybody, particularly when you are playing a big theater like the Guthrie [Minneapolis] for instance. You really needed mikes for people to do subtle things. You could be heard in those theaters by shouting, but they didn't want to shout. Therefore we needed six microphones, and those had to be controlled much like the music. ...Occasionally we had wireless mikes, but almost always they had cable, and they got dragged out across the stage. Not too often did all six get used simultaneously, but sometimes they would. [But six mikes] were potentially always there so there wasn't any jealousy about who had the mike and who didn't.

Planning (and Nonplanning) for Performances

Grand Union had no script, no plan, no structure for their performances, but at least some of the time some of the members made some types of preparations. Mary Overlie's impression was that the members individually prepared themselves for the performances:

I think they actually put thought into what they would do that night. Was it speaking? Was it costume? Was it coming in late? I feel that they all planned out a whole scenario for themselves. ...I remember there was a phone call saying, "I'm going to be whatever tonight, just thought I'd let you know."

"Oh, good" the other member would reply, but that was about the extent of it.[17]

David Gordon substantiated this, in his own case: "When the Grand Union started to function as an entity, I would walk outdoors and think about the next Grand Union performance, and who I would be, and what I would be, and what I would do."[18] Nancy Green said:

> What I planned was my costume. ...How did I feel in what I was wearing? What did I feel like being or looking like? Invariably, I would have changes of clothes with me. ...Sometimes I would totally ignore what I was wearing or wear someone else's costume.[19]

Indeed, nearly everyone brought props and costume changes. Barbara Dilley recalled: "I know that I got into [bringing] costumes and bringing in great bags, a great pillowcase full of costumes, and getting involved in costume transformation and changing clothes in front of everybody all the time."[20]

During the first two years of Grand Union, the company also held rehearsals. Rehearsing for open improvisational performances, of course, was quite different from rehearsing for choreographed performances. Rather than perfecting given sequences, improvisational performers practice, like athletes, training themselves physically, mentally, and emotionally for an upcoming event. Like a basketball team playing an intersquad game, Grand Union practiced mock performances, setting up situations that would serve to strengthen and quicken each member's imaginative reflexes.

Barbara Dilley recalled an early five-week series at a loft space on 13th Street in New York, during which the company rehearsed and performed a great deal: "We rehearsed; we attempted to work on material. ...Some material was explored in rehearsal. Somebody would throw out an idea, we'd fool around with it for a while, and then everybody would get bored."[21] Paxton felt that rehearsals

were not useful for other reasons: "It wasn't a terribly fruitful thing to do. It's so different, to be in the studio together, than to be in front of an audience together."[22] In time, as the company became more confident, both in the form and in themselves, rehearsals were abandoned as being more irritating than helpful.

How to begin a performance was always a challenge, David Gordon remembered:

> A lot of different things were tried by me and other people as well. ...Everything from "We will all meet and be there quietly warming up before the audience gets let in," to "I don't know if I'll show up, I'll see you later," and walking in the door with the audience and walking out into the space and starting to do something, or nothing. In one of the last performances, I stayed in the dressing rooms for the first twenty minutes of the performance getting into a very elaborate getup.[23]

Sometimes the challenge was how to begin in the absence of half the company, Gordon continued:

> A particular performance that I remember was in a loft on 13th Street in which three of us were there. The audience was arriving, and we didn't know where anybody else was, if they were coming or what would happen, and everybody said, "Doesn't everybody know there's a performance tonight?" And then the audience was there, so we went out and started, and sooner or later other people showed up. Sometimes they didn't. Steve being the one who absolutely pushed the situation to the limit. Steve came to an after-performance party without ever attending the performance and said he had wanted to go and see somebody else dance, which he'd done, and I was astonished. It had never occurred to me that you could have a choice like that.

Yet what shocked Gordon as astonishing behavior, Paxton viewed as a way to keep his performance fresh. Not only did he not plan any material or bring any costumes, he purposely might arrive just in—or just after—the nick of time:

116

> Very often what I did was to arrive just before the performance
> or sometimes even after the performance had actually begun and
> join in. It was testing the situation. I didn't want to prepare my
> mind, or rather I wanted to prepare it in different ways. I
> wanted to see what the effect of walking in from the bus trip
> was on the performance. I just walked in with my knapsack.
> Being that the audience thereby knew, if they believed [my
> actions], that I was actually entering with a knapsack from a
> trip. One reason for this was that it was awfully easy for us to
> fall into modes of dancing that looked fairly preconceived.[24]

Bruce Hoover remembered a time when Douglas Dunn arrived late and simply walked into the performance:

> There were no rules about when you had to show up. There
> was a La Mama performance where Douglas didn't show up
> until after we started, but right after we started. ...Douglas just
> walked through. It could have been someone from the audience
> as far as anybody knew, but that was his entrance into the
> piece.[25]

If arriving late worked for Paxton, Barbara Dilley tried the opposite approach during the final months of touring:

> I always went out on the stage [before the performance]. We
> would leave the curtain up, and I would go out on the stage half
> an hour before the piece began and start to move. I just didn't
> want to enter the space anymore in terms of action and reaction.
> I wanted to start from movement.[26]

Once, Bruce Hoover remembers the company decided as a group to begin the performance wearing gray. But usually the goal was to be as spontaneous as possible and allow the unexpected to elicit new responses each time they performed.

Intermissions during the one-and-a-half to two-hour performances were also spontaneous. Hoover describes these unplanned pauses:

Actually, things would get boring and somebody would say, "I think we should stop for a while. What do you all think?" "Yeah, that's a good idea. Let's take an intermission." "We're going to take an intermission, folks. Bye. We'll be back in about fifteen minutes." And it would happen, or even more casually than that, sometimes they'd just go away, and I'd see that and bring on the house lights. Then we'd have an intermission.[27]

Nor were endings planned out. Frequently one of the performers would just say, "Stop. Let's go home." Reviewer Nancy Goldner described the endings of two evenings in the La Mama series (1975):

Trisha Brown brought down the curtain. She said she wanted to go home to her children. David Gordon told her that first she had to speak from the heart, and since she didn't have children, she couldn't be speaking from the heart. Trisha then said she wanted to go home to her child. Now she was talking from the heart, David said, and all the dancers walked off. ...On the following night, the lighting man and the audience terminated the show. One of the six (Barbara Dilley, I think) began to pace around the room, droning into the microphone, "It's time." In a dimming light, the others followed her path, echoing one another's, "It's time." When they converged at the back of the performing space, the lighting man turned off the light, which then became a cue for the audience to applaud with end-of-the-evening finality.[28]

At the Lo Giudice Gallery (1972), though, the audience withheld its final applause, patiently outwaiting the performers, according to Sally Sommer:

[The performers] all seemed to decide that they were going to all sit out at the same time. So they went, and they sat out for a long time, and nothing was happening. The audience looked at them, and they looked at the audience, and I expected the audience to come to an agreement that this was the end, but they didn't do that. They sat there and waited, and it was really a phenomenal moment because that audience was sitting there waiting patiently and eagerly, and by God they were just going

to sit there until something happened. Finally, [the Grand Union] all looked at each other and decided to come into a circle, and they sort of came into a circle, and they would say, "I have an idea," and the other one would say, "Well, I have an idea," and they would act as if they were going to tell each other the ideas. But instead they would just repeat again, "Oh, well, I have an idea." "I have an idea." "Well, what's your idea?" And then Nancy said, "I have an idea. I think we're going to end. I have an idea. Let's end." And then she proceeded to just drag everybody off the space.[29]

Structure (and Nonstructure)

During performances the only rule was that no one could repeat material he or she had done at another performance. Other than that, each unit, or segment of material, could run for as long as anyone was interested, and two or more units could overlap or continue simultaneously. David Gordon remarked:

Material went after material until somebody ran out of breath. We ran on until we were all exhausted and the material was exhausted, and then somebody brought an end to it by opening their mouth about something, so that you could all stand still for a minute and do something else. ...There was no idea that there should be this much of this or that much of something else.[30]

Movement and dance-based units and theatrical-verbal units proceeded without any overt effort to relate consecutive or overlapping segments, although often the random juxtapositions seemed to create a kind of coincidental logic.

As Deborah Jowitt commented in a *Village Voice* review, "they don't make phrases, either, or long patterns of movement, at least not very often. They seem to like chains of short elements."[31] For dance critic Elizabeth Kendall, this segmentation produced startling temporal discontinuities:

> Because nothing is sustained for very long among the Grand
> Union, time erases itself every few minutes. No connections are
> made backward and forward in time, except through references
> to earlier moments in the actual performance or earlier nights in
> that same season.[32]

At any given moment, Gordon said, performers could choose to continue to explore the ongoing unit of material, join in another unit, initiate something altogether new, or simply stop and watch the performance. This last choice was an important aspect of Grand Union's process, allowing members to observe the material others were developing and to catch the overall mood and direction of the evening.

Sometimes the structural discontinuities befuddled or delighted the performers themselves. Steve Paxton told how he reacted to this predicament:

> It could be quite devastating or quite pleasurable. Maybe you
> found yourself later on, actually in something, and this moment
> of "lostness" in fact was several people all groping and finally
> coming to some conclusion together. However, yes, I did
> sometimes find myself lost in performances. Generally what
> happened was I would go offstage and look at what was
> happening and just say, "Boy, is this ever a pile of shit," and
> feel terrible and try to think about what I could do. Put on
> some more music? Sometimes I would fumble around and get
> hysterical backstage, then some way help the situation or just
> stop looking at it. Sometimes I would start doing something by
> myself. But it does occur that you suddenly feel disconnected
> right there in front of an audience and right there with your
> friends behind you dancing away, and you say to the person you
> are dancing with, "What's going on?"[33]

Within the kaleidoscopic structure of discontinuities, several themes became favorites of the group. One theme that appeared in many variations over a period of time was what Barbara Dilley called "a whole sequence about somebody being sick...and talking about illness."[34] The doctor-patient theme, Dilley thought, had first been used after Steve Paxton was in St. Vincent's Hospital in 1971, and the

members of Grand Union went to visit him. An old man in the bed next to Paxton suddenly said, "Oh, God, I'm slipping." Those words became a common reference point, and in performance the utterance "I'm slipping" would usually prompt a doctor-patient scene of some kind.

Dilley felt the medical theme had a powerful, personal effect on audiences, touching the universal fears of not being taken care of, or being badly taken care of, or being misunderstood in illness, or dying because of illness. Douglas Dunn also remembers the doctor-patient material:

> It never was the same. It even had different characters. Although someone was always the patient and someone was the doctor. ...It meant that there were lots of meanings going on for the performers that weren't available to the audience unless they'd seen a lot of work.[35]

In Chicago, Dilley, with a real cough, became the patient; Sally Banes described the sequence:

> The others tried to exorcise the cough, which they began to talk about as a "being" or "spirit," or at least to try to dislodge "her" into another region of Dilley's body.
> In Iowa, the three men had been playing with mirrors, and suddenly they swooped down on Dilley, lying at the side of the stage. "Who referred you to us?" they asked. "When did the pains begin?"[36]

Another medical episode was documented by Sally Sommer:

> First thing I remember happening was David [Gordon] lying over that camp stool and doing some things. Then I remember Trisha [Brown] saying, "How do you feel, David?" And I think that's when David started that coughing thing, saying "I never felt better in my life." Then he coughed and coughed. Next Barbara went over and covered David with a black cloth. ...He was laid out on the floor. Steve [Paxton], who was working separately from this, started asking David how he felt, "How do you feel, David?" David would cough and say, "Never felt

better." Then Steve took off his shirt and pretended it was a stethoscope, and he was listening to David—first his hand, and then the center of his back—and he said, "It never sounded better."[37]

Just as Paxton's hospital stay had given special meaning to "I'm slipping," the company members' shared history, both onstage and off, offered a rich collection of raw subject matter for development in performance. David Gordon called this kind of work "collective unconscious references" and noted, "Grand Union performances are full of them." Steve Paxton described the repeated use of such references as "'organic variations'—like a click, transporting you back to an earlier performance."[38] For audience members who returned again and again to see Grand Union, the self-referential variations constituted an ongoing episodic intrigue.

Some "devices," as Paxton called them, were frequently used to initiate a performance segment:

> They were devices, but devices could get twisted any which way. You weren't sure when you gave a code, so to speak, for "the telephone," or "radio show," "that wasn't right," "let's do it again," or "okay, take it from the middle again"—those are dance rehearsal expressions—which way it was going to go. ...It did not provoke a clear response. ...A device is not intended to be taken in the way that it was taken before. It was "expectable" that it would be unpredictable.[39]

As an example, Paxton described the telephone device:

> The phone call was a theme that did reoccur. Trisha might be over there doing some perfectly abstract dancing, and suddenly get a phone call. You would hear this voice maybe over the mike. "Hello, Trisha?" "Oh, hello, David, how are you?" A phone call would start. It was just a way of adding another layer.

Another device was "scar time," when all the performers displayed their scars. In

122

Sally Sommer's words: "Everyone said, "It's scar time." ...I don't know whether they [had] actually exhibited their scars out front in performance before, but certainly they [always] talk and joke about it a lot. I know that the scars have been used as a theme."[40]

A more complex device was for the performers to describe aloud to the audience their thoughts and intentions as they performed, or to overlay a descriptive monologue on another performer's actions. The effect of the self-commentary was often quite comical:

> Dunn discourses on his method while starting a very long sequence. He falls, gets up, turns around, falls, turns over. [He says] "Right now I'm starting a very long sequence." He continues dancing. "I don't think I'll do the whole thing. This is the end," doing some jumps and quick footwork. "This is the middle," he says, running back to a point near where he started and falling again.[41]

Dropping one's performance persona and "loitering on stage" was yet another favored device, Steve Paxton recalled:

> As Doug Dunn liked to say, "Loitering on stage was a definite asset." Waiting for the moment when you became engaged in something, either because you were called on or because you decided to initiate something on- or offstage. You could also go "offstage and loiter." The stage was not a sacred area.[42]

Thus in a split second a performer would shift from playing a fictional character to playing his "real" self, to playing amalgams of "real" and fantasy roles, including impersonating his fellow performers. The audience was finally never quite sure what particular identity a performer was projecting. Sally Banes describes this dizzying "reality warp":

> The roles, characters and persona transformed easily to accommodate the changing flow of situations. ...For instance, a "real" Dilley interacting with a "fabricated" Gordon, or a

Lewis who has been instructed by Brown to imitate Paxton. ...[They were] people who seemed to operate outside any established rules for reality—ordinary, dramatic, or fictional.[43]

At times, though, outrageous behavior was prized for its unconventionality rather than for any metacritical point. Nancy Green recalls a performance where she and Steve napped on stage for about fifteen minutes: "But that was still participating because we were there in view."[44]

Breaking Taboos

The members of Grand Union had different ways of mentally preparing themselves for the performances. There was the use of drugs—by some but not others—particularly during the early years. Barbara Dilley speaks very candidly about this:

> Well, you have to remember that we were in our thirties during this time, so all of the drug culture hit most of us after we were professionals. It was New York City, and everyone looked like refugees, and you know everyone got stoned all the time. The group was not a drug-taking group, but some of us often got stoned in the beginning. Marijuana was not that big a deal. I mean you didn't become an idiot. Some people never did [it]... this was individual. Nancy [Green] liked to smoke a lot. I don't know that Doug [Dunn] did very much. Steve [Paxton] smoked always off and on.

"I remember doing some mescaline. There was a month-long series at the 13th Street loft, and I got so fatigued and didn't want to perform anymore, and that's when I started doing the mescaline. I only think I did it once or twice."[45] Mescaline, Dilley felt at the time, helped lower her inhibitions:

> I took organic mescaline and went to the performance. I was very unhappy, and it was very hard for me to perform, so I was

desperate. ...For me mescaline was "very vocal." It stimulated my whole vocal work, and it was in this period that I was discovering my voice, and I remember working in that performance with the mescaline, on my voice. That was for me, on a very personal level, a real breakthrough because I was a trained Cunningham dancer. I had no voice. That was when we were discovering and uncovering. I think it popped through a lot of our conceptualizing. It broke down your censorship a lot. Combined with somebody else being outrageous and your censorship falling away, you did things that you hadn't ever thought of doing before, and solutions arose, and yet your discipline didn't disappear.

As time went on, Dilley recalled, drug use was less frequent "because things were so tense, and the performance was so high-powered already...one isn't so interested in drugs any more because it's so self-absorbing."

Steve Paxton also talked about experimenting with drugs, to see how an altered state of consciousness would affect his performance:

At that time, the end of the 1960s, it was a very provocative thing to do. It seemed like pot, especially, had an incredible effect on people socializing and therefore might have an effect on the empathy [between performers] in the performance. [But] I found it disorienting. I felt disassociated. I didn't find it useful, unless I knew somebody else was also smoking pot. It was just the idea that someone else was in the same space, [the] drug area that I was in, would make me more comfortable, but otherwise the people who didn't smoke set us apart. It made me feel insecure, so it didn't seem very useful.

I remember Nancy "tripping" to a performance, and she had to leave rather abruptly. I think it was some hallucinogenic drug, maybe LSD or possibly mescaline. I can't imagine that being helpful, and in fact that was the first performance where she got into the mode, as I recall, of not being active in the performance but being passive and not knowing what to do. In this particular instance, it was traumatic enough that she left. She was feeling very bad. I think the [use of drugs] in some way triggered a mode for her that continued through the rest of Grand Union.[46]

As Paxton summarized it, the uninhibiting effects of drugs were, paradoxically, inhibiting: "You are pushed into a much deeper stage of awareness of yourself than you normally are, and that can be very disturbing. It can actually be quite inhibiting."

Nancy Green remembered the performance Paxton mentioned:

> I did use drugs, and sometimes it got in the way of performances. Once I didn't show up at all, or I came, went into my paranoid state and went home. ...Everyone didn't do that, and I didn't do it all the time. I did use grass sometimes, and it did put me in a relaxed state physically. You know it's like a warmup. I would use it as a warmup. Get you concentrated into your body and moving. There's a certain awareness that it brings, but there's a certain dullness that it brings, also.[47]

David Gordon says he never used drugs. In a recent article, Yvonne Rainer commented briefly, "Finally I had to drop out [of Grand Union] because I couldn't face those performances without being stoned."[48]

The idea that using drugs, a big part of the social environment of many artists in the 1970s, would make the members of Grand Union feel more relaxed and less inhibited was explored by some, but not by others. The conclusion seems to be that it usually did not help to alleviate fears but rather caused a certain amount of paranoia and often isolated the performer from his/her fellow performers.

The company also gave itself permission to explore the taboo on nudity in performance. Nancy Green discussed this choice as an aesthetic one: "We just came into the art world, we became moving sculpture, performing sculpture, in the sense of being nude. It fit into the piece [of dance] that evening. There was a respect for the body and movement."[49] In one early performance:

> Steve [Paxton] meanwhile has emerged nude and quivering from the pink cloth, having finally shed both clothes and cloth. The

126

metaphysical effect is powerful. He dances a slow, sensuous dance—arms widespread, torso moving gently. Barbara [Dilley] joins him, doing a version of her own while facing him. The music ends. Barbara walks to one end of the space, disrobes, rewinds the tape, and—nude—returns to her original position. They repeat the dance.[50]

A documentary video of the Lo Giudice Gallery performances (1972) also includes some nudity: Nude above the waist, Nancy Green walks into the performing space. Steve Paxton, shirtless, joins her. They sit on the floor for a long time, their arms around each other in a passive embrace. Finally they get up and exit—leaving the viewer with the impression that they had initiated the scene but not had a clear sense of how to develop it.

There are no references to nudity in the reviews of the final years of Grand Union. The idea of nudity in performance, it seems, like the use of drugs, was tried for a while and later discarded.

The Audience

The audience, of course, always plays an important part in any performance. Grand Union audiences, however, were expected to be—and were—more actively engaged in the performance than typical concert goers. The audience was there to complete the pact between artist and community, to observe and encourage a process rather than partake of a finished product. Although audience members were not called upon to join the performers (a technique used by the Living Theater and other experimental groups), they were asked to look at the performers and the act of performance in a new way. Steve Paxton said:

> We were asking people to find more in that reality [on stage] than they've been invited to before, because in the past theater has tended to stylize people. ...You [the Grand Union

performer] assume a persona, or you dig into your own persona
and take elements and present them. Sometimes our sexuality
is present. Sometimes our mentality is present. We have added
the colors that weren't allowed to exist before [on the stage].[51]

Mary Overlie compared the audience's role to that of "watching a very good
game of chess."[52] The intellectual and emotional power of this "artistic seeing,"
Overlie felt, provided a thrilling experience for the whole audience. "That was a
thrill itself to be in an audience who were just thrilled...because of seeing in this
special context."

Barbara Dilley described how the audience observed the process of making
the concert, of putting it all together:

That's why the audience got off on it. Our rules and agreements
were worked out right in front of the audience. [For example,]
somebody would say, "Would you please be a tree for the next
five minutes?" And the audience would see the request being
made, they would see the person either say, "Yes, I'll be a
tree," and then not being a tree, or "Yes, I'll be a tree," and
being some kind of tree. It was this constant seeing—how we
built or structured a particular event and who participated in it,
and the ways [each of us] helped or resisted, supported or
undermined [the intentions].[53]

The audience had a kind of power of its own, Dilley added:

There was some kind of exchange of energy. Whether we felt
they were getting bored, and then somebody thought of some-
thing clever to do. ...There was definitely a sense that material
was [encouraged] by the audience—laughter, for instance.
Laughter being the thing that was the most obvious response.
They didn't applaud something that was beautiful, so it tended
to always move toward that sense [the humorous]. [Performers]
would rise to the occasion and continue to develop this [humor-
ous] material, if the audience was into it.

The audience was also implicated in the performers' embarrassment and vulnerability, as Steve Paxton explained:

> I've been embarrassed to the roots of my being. Just so ashamed. That's been true right from the beginning actually. ...It's part of the material. ...The audience has to accept that. They cannot sidestep the issue of the performer sometimes experiencing embarrassment. It [the audience] is not looking at selected things, as in historical drama.[54]

The audience members in New York were mostly intellectuals, artists, and other dancers—"people who don't go to the usual things," Bruce Hoover labeled them, "people who knew about the Grand Union, or had at some time in their life seen them or some friend of theirs had seen them."[55] But outside of New York, the audience profile was very different. In Hoover's characterization:

> There were those people who were coming to a "dance concert" or were part of the subscription series. Well, there is no way to prepare people like that, who come in their suits and ties and nicely dressed for their night out at a "dance concert." These people would leave. They would be appalled. I was onstage and I could watch some of this behavior.

In and out of New York, Hoover noted, audience members would come backstage after the performance, even if they didn't know any of the performers:

> The reason [was] that they have been privy to a kind of open process of these people [the Grand Union]. The same kind of performer-audience barrier didn't exist in the formal way which most theatrical things are presented.
>
> In Missoula, which was the last performance, there was shouting from the audience. Somebody was really angry, and he came backstage after the performance. I think he was a little drunk. He sought out Steve and just started railing at him. "How dare you all do this?" How dare you do this kind of thing? This is just disgraceful that you are doing this on the stage." Steve really handled it brilliantly. His calm and his peace [are] able to deflect that kind of energy.

Many of the reviews briefly remarked on the unusual experience of watching Grand Union perform:

> Sometimes it's interesting to watch them watching from the wings, because you can see their mind warming up.[56]

> What I appreciate most about the improvised evenings is being able to see the processes that either instigate changes or block it. ...it means a great deal to me to watch performers "making up their minds." ...I think they risk the most in being willing to show themselves at a loss.[57]

Trisha Brown was well aware of this risk: "We also realize the possibility of failure at times. Failure is inherent to our method. The audience realizes this. That's why they usually bring a picnic lunch."[58]

More than a picnic lunch, the audience brought to the Grand Union performance a lively curiosity tempered by a patience for waiting for something to happen, and a fascination with observing a group of highly talented people "make it up" as they went along. As Yvonne Rainer said in 1972: "I guess that's why a lot of people follow us so closely. They want to be in on it, they very much identify with the individual performers, the real personalities and their successes and difficulties. That's what fascinates them."[59]

NOTES TO CHAPTER VI

[1] Sally Banes, interview with Trisha Brown, 1973.

[2] Interview with Steve Paxton, Dec. 1984.

[3] Banes, interview with Brown, 1973.

[4] Interview with Douglas Dunn, Nov. 1983.

[5] Interview with Bruce Hoover, Mar. 1985.

[6] Interview with Dunn, Nov. 1983.

[7] Interview with Dunn, Nov. 1983.

[8] Interview with Dunn, Nov. 1983.

[9] Transcript of video of Lo Giudice Gallery performance.

[10] Interview with Hoover, Mar. 1985.

[11] Interview with Dunn, Nov. 1983.

[12] Interview with Hoover, Mar. 1985. All the comments by Hoover in this section are from this interview.

[13] Interview with Dunn, Nov. 1983.

[14] Interview with Paxton, Dec. 1984.

[15] Interview with Nancy Green, Nov. 1984.

[16] Interview with Dilley, Nov. 1984.

[17] Interview with Overlie, May 1983.

132

Interview with Gordon, Mar. 1985.

[19] Interview with Green, Nov. 1984.

[20] Interview with Dilley, Nov. 1984.

[21] Interview with Dilley, Nov. 1984.

[22] Interview with Paxton, Dec. 1984.

[23] Interview with Gordon, Mar. 1985.

[24] Interview with Paxton, Dec. 1984.

[25] Interview with Hoover, Mar. 1985.

[26] Interview with Dilley, Nov. 1984.

[27] Interview with Hoover, Mar. 1985.

[28] *The Nation* 12 Apr. 1975.

[29] Sally R. Sommer, audiotape description of performance, 1972.

[30] Interview with Gordon, Mar. 1985.

[31] Deborah Jowitt, *Village Voice*, cited by Baker, "Grand Union: Taking a Chance" 46.

[32] Kendall, "Grand Union" 54.

[33] Interview with Paxton, Dec. 1984.

[34] Interview with Dilley, Nov. 1984.

[35] Interview with Dunn, Nov. 1983.

[36] Banes, *Terpsichore* 216.

[37] Sommer, audiotape description.

[38] Baker, "Grand Union: Taking a Chance" 46.

[39] Interview with Paxton, Dec. 1984.

[40] Sommer, audiotape description of Lo Giudice series, 1972.

[41] Banes, *Terpsichore* 216.

[42] Interview with Paxton, Dec. 1984.

[43] Banes, *Terpsichore* 210.

[44] Interview with Green, Nov. 1984.

[45] Interview with Dilley, Nov. 1984.

[46] Interview with Paxton, Dec. 1984.

[47] Interview with Green, Nov. 1984.

[48] Rainer, "Engineering Calamity with Trisha Brown," *Update*, *Dance/USA* Oct. 1986.

[49] Interview with Green, Nov. 1984.

[50] Artservices archives, found manuscript, author unknown. The same scene is described by Deborah Jowitt in a *Village Voice* review, 14 Jan. 1971.

[51] Interview with Paxton, Dec. 1984.

[52] Interview with Overlie, May 1983.

[53] Interview with Dilley, Nov. 1984.

[54] Interview with Paxton, Dec. 1984.

[55] Interview with Hoover, Mar. 1985.

[56] *The Nation* 12 Apr. 1975.

[57] *Village Voice* 17 May 1976.

[58] Baker, "Grand Union, Taking a Chance" 46.

[59] Koch, "Performance" 56.

CHAPTER VII

THE END OF AN ERA

One wave of the dance revolution inaugurated by Merce Cunningham in the 1950s and continued by the Judson Dance Theater in the 1960s crested in the "no rules, no theory" improvisational dance theater of Grand Union in the 1970s. As Steve Paxton summarized it, Grand Union was "one end of...one aspect of the Judson's people's journey together."[1]

However, by the end of the 1970s there was a general consensus in the art world that the frenzied forward rush of the sixties had come to a dead-end, that all the great adventures of the twentieth century, including the modern movement in the arts, had reached the end of the road. The euphoric, altruistic hope that art could change the world could not be sustained. After all, despite the richness and vitality of the artistic breakthroughs rung up during the sixties, little progress had been made in reducing the threat of nuclear war, in decreasing racism and poverty, or in halting the destruction of the environment.

By the late seventies, the national pendulum was moving toward more conservative values and politics, toward insularity and materialism, and American dance also returned to more conservative and traditional modes. Whereas in the sixties dance performance had been as much a demonstration of ideas as of physical activity, the dance of the early eighties was about technical virtuosity and slick production values. Common was the spectacle of the trained super-dancer executing nearly impossible complicated movement. The highly rehearsed, finely polished, costumed performance was in; improvised pedestrian dance, scratchy LPs,

found props, and a casual approach to concerts were out. The new choreographers tended toward movement that was fast, energetic and athletic. Curiously, their emphasis on technical virtuosity and proscenium presentation harkened back to the traditional ballet aesthetic, where virtuosity has always been of primary importance.

By the late 1970s, interest in experimental group improvisational modes petered out. Some late legatees of the Judson period—including Lucinda Child and Meredith Monk—continued to explore individual terrains of dance, but the "do anything and it might be art" era was over, and the utopian vision of nonhierarchical performance collective largely faded. Richard Schechner attributes part of the disillusionment to the American cult of individuality:

> Even dreaming of collective action in a society as caught up in individual mythology, ritual, and media as America is, is hard. To pursue this dream of collectivity into action while making theatrical works in an environment of bruising poverty is even harder.[2]

Also working against performance collectives and improvisational companies were, ironically, the policies of the National Endowment for the Arts (NEA), whose dance grants program was intended to provide a measure of economic support for performers. Understandably, the NEA wanted to know what it was sponsoring, what it was going to get for its money. At the NEA, grant proposals written by collectives and improvisational troupes were viewed with circumspection: Who was in charge and what works would be performed? Applicants soon learned to fudge these questions, naming a single choreographer for a work that would be created by the group, and describing in detail works whose performance would be improvised.

But given the difficulties of making a living as a dancer, the seduction of government support was hard to resist. To garner funding, many up-and-coming dance companies and choreographers understood the need for a well-packaged art

product that would appeal to bureaucratic agencies and a wider public. New York dance artist Nina Martin, a one-time member of David Gordon's company, explained: "The younger dancers, they know there's not much support out there [for improvisation]. [Improvisational artists cannot promise] 'We'll send you a videotape, and this is what you're going to get'—it's *not* what they're going to get."[3] As Mary Overlie observed, by the early 1980s the lack of support for improvisation extended beyond funding agencies to audience and fellow dance artists: "When you invest your life as a dancer in this society, you're already asking for it [i.e., for a life with no monetary rewards]. With improvisation, you're in a context where even in the dance world you're not making an investment [that will pay off]."[4]

The Legacy of Grand Union

Despite the ensuing lack of interest in collective improvisational approaches to performance, evidence of Grand Union's legacy can be glimpsed in the structure and content of diverse choreographers" works. Indeed, some of the innovations that seemed so outrageous in the sixties are now commonplace, almost conventions: the incorporation within a dancework of a considerable amount of talking, singing, other verbal activity, theater scenes and vignettes; the contrapuntal play of performers' "real" personalities against their stage personas in direct addresses to the audience and fellow performers; the use of free association, juxtaposition, overlapping, interruption and subversion as compositional devices for structuring seemingly unrelated fragments of material.

The legacy of Grand Union is also apparent in the subsequent work of its members. Because of the company's insistence on always moving forward and not repeating itself, Grand Union was not a place conducive to exploring and

developing new ideas born during rehearsals or performances. However, several company members later developed work based on ideas first hit upon in Grand Union. For example, Steve Paxton recalls how a task Trisha Brown assigned during a Grand Union performance inspired her full-length dance *Line Up*:

> She asked everyone to line up. How everybody took that term *lineup* was very amusing to her. It's all about different kinds of lineups. ...Some of them stood up straight, some of them got next to someone else, some of them lay down, some got next to a line.[5]

Paxton also credits Grand Union as the inspiration for and the beginnings of Contact Improvisation, a dance form that became a grassroots movement supported by large numbers of young dancers in America and Europe: "The vision of contact improvisation was in part provoked by the constant flowing forms we encountered when Grand Union was cooking."[6] David Gordon recalled: "In almost every single Grand Union concert, Steve and Barbara, and/or Steve and Trisha, and/or Steve and Douglas and/or any of those people did some version of some extended improvisational duet or trio which had "contact" roots.[7]

Like a Grand Union performance, Paxton's early investigations into what he called "the freedom-and-space idea" had to do with process and unpredictability:

> Being able to launch myself off the planet, not being afraid of how I might land. ...You might be in and out, just letting a movement flow, in ten seconds. The momentums in the body, in arms and legs, flow for a while, then come to a pause in that flow. If you decide to let momentum take you, where does it take you? It's unpredictable. You wind up in some position you didn't envision. What is your next choice? That was the process.[8]

The Oberlin residency of Grand Union in 1972 gave Paxton the opportunity to "explor[e] the parameters of the basic [Contact Improvisation] duet form: What

happens when the partners give weight, lift, carry, wrestle each other, give in to the floor and gravity, all in a way that breaks out of typical male habits of aggression or fear of tenderness?"[9] At Oberlin, Paxton recalled, he wanted to see how the technique could be taught. His students, he acknowledged,

> pushed me to go further in three weeks than I ever thought I could. I then realized that the material had a kind of organic base, so it wasn't so tricky to pick up as dance technique. Then it was a matter, not [of]..."Is this a mode?" [but of] "How can this be conveyed?" What is an effective way of teaching this kind of material, and what does it require? Sort of a cataloguing of material that has always existed in and out of wrestling and embracing. A lot of duet endeavors are about the touch language.[10]

Later in 1972, Paxton gave a concert in New York with students from Bennington, Oberlin, and Rochester, a concert that officially introduced Contact Improvisation. Two descriptions—one by Sally Banes, the other by Kathy Duncan—suggest how the form developed during the 1970s:

> The movement material is not exactly commonplace, though specific moments often look familiar. It is movement that originates in a variety of "couple" situations, ranging from greeting a friend to making love to brawling to martial arts to social dancing to meditation. There are impressive lifts and falls, evolving organically out of a continuous process of finding and losing balance. There is a give and take of weight, but also of social roles, of passiveness and activeness, of demand and response.[11]

> The six men and women work in pairs, bearing each other's weight, lifting, hauling each other, falling on each other, throwing themselves at each other. ...(Sometimes they don't make it and take bone-cracking falls)....
> One of the most beautiful things is when a body deflects or slides naturally off another body...a dancer might place his/her head in the path of someone just as he/she starts a forward roll. ...The way the body's natural protective reflexes take over,

> when someone falls backward from riding someone's shoulders.
> ...One tall man catapults himself over another taking him along
> in a wild forward roll that heads straight into one of the
> pillars.[12]

The Contact Improvisation groups and the network of contactors across the United States are characterized by what Sally Banes calls a "populist spirit" and a collective, democratic philosophy. And like Grand Union performances, Contact Improvisation concerts resemble workshops in that the audience is asked to observe the performance without any intention on the part of the performers to entertain. A performance will contain more and less exciting moments, and the audience, as in open improvisation, is engaged in watching a process unfold. Although performers make no conscious effort to express emotions—"we're focused on the phenomenon rather than on the presentation,"[13] Paxton says—audience members experience kinesthetic and visceral reactions, and a heightened sense of elation as they observe and empathize with the performers.

In addition to Paxton, the most prolific and successful dance artists of Grand Union—in terms of developing their own dance companies and bodies of individual work—are Trisha Brown, David Gordon, and Douglas Dunn. Surprisingly, several former company members deny seeing any significant traces of the Grand Union influence on their later work. But the comments of their fellow dancers, their students, and other observers suggest that Grand Union has exerted a greater power than the members themselves are perhaps aware of.

For example, David Gordon has said that he cannot discern the influence of Grand Union in his later work: "I can't find the effect. I sometimes look for it. I sometimes even remember some haphazard or arbitrary series of connections which were amazing, and I try to figure out how to get that to happen in my work, and I don't know how."[14] However, in Gordon's first choreographed dance after Grand Union dissolved, *Not Necessarily Recognizable Objectives*, one can discern

the improvisational "look" of spontaneity translated into a set work. The dancers discuss among themselves, in a conversational mode, the next moves they will make. And at another juncture, they comment between themselves during Gordon's solo section: "He is the star, so he gets to do a solo." The choice of material has a whimsical, casual air reminiscent of Grand Union.

A later dance, based in structured improvisation, is described by Nina Martin, who danced with Gordon's company:

> It was all about interference. There were many cues in the piece, and you would walk and talk, but any [of the performers] had control. [If] someone gave a cue, and the cues were very ingenious, [it would change the activity]. Then there was a sort of general activity to weave it all together—just being in a line trying to get to the front. ...You could [also] call a cue which would set up some dialogue. You could let it go on as long as you want, or cut it short and pull back and do another cue.[15]

Gordon had, of course, used improvisation within a set framework as early as the Judson period, but one cannot imagine that his ideas about structured improvisation were unaffected by his Grand Union work.

Simone Forti, a New York dancer who followed the work of the members of Grand Union, both in and outside the company, detects in Gordon's later work a residue of Grand Union's brand of associative logic: "He doesn't free associate on stage at the moment of performance, but he puts logic together in that multiple [layered] logic kind of way. ...He uses dialogue in very fanciful nonsensical ways that are very close to [Grand Union].[16] Nonetheless, over time Gordon's work has become more conservative. In the late eighties his Pick Up Company is fully choreographed, well-rehearsed, professionally staged, and fashionably costumed. Except for occasional flashes of tongue-in-cheek humor, very little of the up-ending free-wheeling Grand Union spirit remains.

In contrast, Douglas Dunn, who views his later work as a melding of the Grand Union and Cunningham influences, credits Grand Union with two specific contributions to his way of working: Grand Union taught him the need to make choices in relation to one's resources and opportunities at any given moment, and Grand Union influenced his approach to creating new dance material by teaching him to pay more attention to context, rather than starting with a preconceived image or idea. For the dance *Lazy Madge*, Dunn explains, he made himself available in his studio from 10 a.m. to 5 p.m. each day. He worked with whichever dancers showed up, letting them decide their own rehearsal schedules: "They had to daily say, 'I want to go dancing with Douglas today." ...I wanted real commitment on a day-to-day basis. ...maybe these solutions [to rehearsal scheduling] would never [have] occurred to me had I not experienced...Grand Union."[17]

The job of teaching improvisational techniques to a new generation of dancers was most ably filled by Barbara Dilley, who continued to play a significant role as a theoretician of improvisational approaches. Dilley contributed a body of improvisational techniques first explored in her company, Natural History, and then developed into specific teaching tools and improvisational exercises. Mary Overlie, a member of Dilley's company who went on to teach improvisation, says:

> These forms started to emerge just in their own forms...one was [called] "corridors" and another was "the box"...there's an inside linear space that's the grid where everything is set. You don't violate it with diagonals or circles. They are like spatial places. [These are] wonderful teaching tools.[18]

Nina Martin remembers that when she first came to New York, Dilley's teaching structures for improvisation were quite popular. "Corridors," she explains, is a structure where you "just basically divide space up into little alleys, and you dance up and down your alley. Very simple. Very effective."[19]

Finally, although no one group has carried on the Grand Union tradition, one of the strongest trends in dance in the late 1980s has been the choreographic integration of elements of theater and dance. In this sphere Grand Union "has been a big influence in a broad way," Simone Forti says, linking "a lot of the verbal work that people in their twenties and thirties are doing" to Grand Union precedents.[20] She also credits Grand Union with popularizing the "playing off between the waking state and the dream state. The people loved them, and I think they opened up that channel between logic and everything else that goes on at the same time. I imagine they made people more aware of themselves...of the dimensions of their consciousness."

In recent years a small number of dancers have continued to explore "vocal/dance/theater." The best-known American practitioner, perhaps, is Meredith Monk, a later member of the Judson group who has maintained a consistently respected, but relatively low profile. Performing in lofts and small spaces, Monk and her company members present a kind of dance/theater that includes visual images, movement, gesture, symbol, and voice. But the most exciting newcomer to this genre is Tanztheater Wuppertal, headed by West German choreographer Pina Bausch. Bausch's productions represent a great leap in the scale, sophistication and creative possibilities inherent in highly choreographed, intensely rehearsed, full-length evening works that incorporate theater images, movement sequences, and dramatic verbal content. Her professional company of twenty-five highly trained dancers has been enthusiastically received all over Europe and the United States, having struck a responsive chord in audiences.

Rosalee Goldberg correctly discerns the influence of the seventies in Bausch's compositions: "Taking the permissive vocabulary of the seventies as her yardstick —from classical ballet to natural movements and repetitions—Bausch devised adventures in visual theater."[21] But "adventures" hardly begins to describe

the powerful emotional expression Bausch's dances generate. Accompanied by an eclectic assortment of music, Bausch's productions involve sets, costumes, and large casts engaged in pedestrian, dynamically combustible movement, theatrical vignettes and dialogue, stunts and elaborate stage effects. Political, feminist and, although abstract, always full of messages, Bausch's work offends, defends, confronts, charms, and all but hits the audience over the head to make its point.

The dance press has labeled Bausch's style "neu-German Expressionism," a label that acknowledges Bausch's clear indebtedness to the German expressionist dance of Mary Wigman and Kurt Joos. But her work's gutsy rawness and its innuendoes of violence also hint at the influence of American iconoclasm and tradition bashing. Indeed, Bausch did study in the United States in the late fifties, attending the Juilliard School where she studied with Antony Tudor, and later danced as a member of the Paul Sanasardo Company, before returning to West Germany in 1962. Though Bausch is truly her own person, one wonders if part of the public and critical enthusiasm for her dance theater owes something to the groundwork laid by performance groups like Grand Union: a developed taste for directly confrontive performance.

Another choreographer whose pieces integrate dance elements, music, and theatrical setting, dialogue, and narrative is Martha Clark, an American. More dancerly and subtle than Bausch's productions, Clark's works have an intellectual-literary resonance.

Looking beyond dance to contemporary international trends in all the performing arts, Alan Kreigsman, dance critic for the *Washington Post*, cites a rather Grand Union-like amalgamation of different genres and idioms as a hallmark of our time:

> "Crossover" may be the basemark of the performing arts of the present era. The phenomenon at any rate—the bridging of gaps, the mingling of metiers. ...The borderline between dance and

theater—always, perhaps, on the fuzzy side, at least in the gray area of the avant-garde—has grown less distinct. More and more one finds oneself repeating fundamental questions. Is this dance? Is this theater? Does it matter? ...The questions reflect a large, and apparently global movement toward the *elision* of boundaries among art forms. The trend toward a fusion of dance and theater is one example;...[a] tendency is evident within the individual arts, in the erosion of distinctions between idioms, styles, and genres.[22]

Although it is too soon to come to conclusions or to judge the legacy of the seventies, we can make some educated observations. It is clear that the modern dancers of the sixties were in revolt. Discarding their heritage, these avant-garde artists sought and found new forms and gained such acceptance that their credos became the orthodoxy of the age. As we have seen with the Grand Union, these courageous artists, with the support of their fellow travelers, rushed forward headlong toward what later appeared to some observers a dead-end. But perhaps not.

Rather than a dead-end, we see an art movement that stopped to catch its breath after an exhilarating, innovative burst of creativity, a movement that has paused to reflect, to integrate promising innovations and to discard approaches that do not work, to rethink alternative options and then decide on new directions. Many of the breakthroughs in dance came so fast in the sixties and seventies that only now can we begin to appreciate the extent and richness of those new ideas, structures, and forms. The next generation of dancers and choreographers have inherited the job of making sense out of one of the richest, most courageous and least self-conscious creative periods in dance history, a period that profoundly changed the direction of dance performance.

NOTES TO CHAPTER VII

[1] Interview with Steve Paxton, Dec. 1984.

[2] Richard Schechner, *The End of Humanism* (New York: Performing Arts Journal Publications, 1982) 37.

[3] Interview with Nina Martin, Feb. 1986.

[4] Interview with Mary Overlie, May 1983.

[5] Interview with Paxton, Dec. 1984.

[6] Paxton, quoted in Sally Banes, *Terpsichore in Sneakers* 229.

[7] Interview with David Gordon, Mar. 1985.

[8] Interview with Paxton, Dec. 1984.

[9] Sally Banes, "Steve Paxton: Physical Things," *Dance Scope* 13.2&3 (1979): 18.

[10] Interview with Paxton, Dec. 1984.

[11] Banes, "Steve Paxton" 18.

[12] Kathy Dunn, "Steve Paxton," *Village Voice*.

[13] Banes, *Terpsichore* 67.

[14] Interview with Gordon, Mar. 1985.

[15] Interview with Martin, Feb. 1986.

[16] Interview with Simone Forti, Mar. 1985.

[17] Interview with Douglas Dunn, Nov. 1983.

[18] Interview with Mary Overlie, New York City, 18 Feb. 1986.

[19] Interview with Martin, Feb. 1986.

[20] Interview with Forti, Mar. 1985.

[21] Rosalee Goldberg, *Performance Art from Futurism to the Present*, rev. ed. (New York: Harry N. Abrams, 1988) 205.

[22] Alan Kreigsman, *Washington Post* 24 Nov. 1985.

APPENDIX A

It is not necessary to read this program prior to performance.

WHITNEY MUSEUM OF AMERICAN ART
March 31, April 1, April 2, 1970

CONTINUOUS PROJECT—ALTERED DAILY

By Yvonne Rainer

Performed by

Becky Arnold, Douglas Dunn, David Gordon, Barbara Lloyd, Steve Paxton, Yvonne Rainer and others.

Objects and "body adjuncts" by Deborah Hollingworth
Films by Jack Arnold (The Incredible Shrinking Man)
 Michael Fajans (Connecticut Rehearsal)
 Phill Niblock (Line)
Sound supervision by Gordon Mumma

THE AUDIENCE IS INVITED TO GO TO ANY OF THE THREE PERFORMANCE AREAS AT ANY TIME. HOWEVER, PLEASE *DO NOT WALK ACROSS* THE MAIN PERFORMING AREA, BUT PROCEED AROUND THE PERIPHERY OR ALONG THE WALLS TO GET FROM ONE PLACE TO ANOTHER.

Continuous Project—Altered Daily takes its name from a sculptural work by Robert Morris. It has altered and accumulated very gradually at Pratt Institute in March 1969. It was there that I first attempted to invent and teach new material during the performance itself. What ensued was an ongoing effort to examine what goes on in the rehearsal—or working-out and refining—process that normally precedes performance, and a growing skepticism about the necessity to make a clear-cut separation between these two phenomena. A curious by-product of this change has been the enrichment of the working interactions in the group and the

150

beginning of a realization on my part that various controls that I have clung to are becoming obsolete: such as determining sequence of events and the precise manner in which to do everything. Most significant is the fact that my decisions have become increasingly influenced by the responses of the individual members. Although it cannot be said that Continuous Project is the result of group decision-making as a whole, it is important to point out that there are details throughout the work too numerous to list that should be credited to individual responses and assertiveness other than my own, or to the manner in which we have come to work together, i.e., freely exchanging opinions and associations about the work as it develops.

I gratefully acknowledge the assistance of the John Simon Guggenheim Foundation in the form of a fellowship, which during the past year has permitted me to work unharrased by the fact that I normally do not make a living at what I do.

Rudimentary Notes Toward a Changing View of Performance

Levels of Performance Reality:

 A. Primary: Performing original material in a personal style.

 B. Secondary: Performing someone else's material in a style approximating the original, *or* working in a known style or "genre."

 C. Tertiary: Performing someone else's material in a style completely different from, and/or inappropriate to, the original.

Elements used in Continuous Project (not all of the following occur during any one performance):

 1. Rehearsal: Performance of previously learned material that is not in polished condition (i.e., has been insufficiently rehearsed), thereby necessitating verbalizations, repeats, arguments, etc.) The material itself may be re-learned (having been performed at an earlier date) or may be having a first performance, in which case all the "kinks" may not have been worked out (cf. "working out").

 2. Run-thru: Polished performance of material. May involve verbalizing because of prearranged "signals" or actual response during performance. (See "Behavior.")

3. Working out: Creation of new material in performance. It may result in intense response-behavior kind of activity. It can resemble "rehearsal" and may involve "teaching."

4. Surprises: Material (objects, activity) introduced without previous knowledge of all the performers.

5. Marking: Performances of previously learned material in the absence of some of the conditions necessary for polished performance, such as adequate space, proper number of performers, proper expenditure of energy, etc.

6. Teaching: A performer teaches previously learned material to one or more performers who do not know it, or choreographer invents new material.

7. Behavior:

 a. Actual: individaul gestural and verbal activity spontaneously occurring in performance of a predetermined situation. Can occur during any of the above or in "b."

 b. Choreographed: behavior that has been observed, then learned, edited, or stylized prior to performance.

 *c. Professional: the range of gesture and deportment visible in experienced performers.

 *d. Amateur: the range of gesture and deportment visible in *in*experienced performers.

*The distinction between these two categories is becoming rapidly more blurred as seasoned performers begin to reliquish their traditional controls and so-called amateurs become more expert in the new dance modes.

A selection of roles and metamuscular conditions affecting (though not always visible during) the execution of physical feats.

adolescent
angel
athlete
autistic child
angry child
Annette Michelson
bird
Barbara Streisand
Buster Keaton
brother
Betty Blythe
black militant
confidante
Carrie Oyama
competitor
energized dancer
Edward Sloman
enemy
follower
Fidel Castro
friend
feminist
George Sugarman
girl with hare lip
head
husband
hard drinker
Hollis Frampton
hunch back
leader
Louise Brooks
lover
Lucinda Childs
middle-aged fat man
male nude
mother
Martha Graham

macrobiotic foodist
Michael Keith
Norma Fire
old person
out-of-shape dancer
old teacher
playing child
pregnant woman
pompous nobody
peer
redhead
Richard Forman
sick person
swimmer
short woman
schizophrenic
senile old lady
tired person
tall girl
12-year-old ballerina
weight lifter
W. C. Fields
young woman
young man
anger
convalescence
celibacy
constipation
catatonia
drug-induced state
discipline
diarrhea
exhilaration
equanimity
fatigue
fear
gas

good muscle tone
in the pink
impotency
large bone structure
malnutrition
not in the pink
overweight
puberty
pleasure
pregnancy
pain
power
relaxation
responsibility
senescence
sciatica
terminal cancer

APPENDIX B

CHRONOLOGICAL LISTING OF PERFORMANCES OF GRAND UNION

1969–1970

Pratt Institute	March 1969
University of Missouri, Kansas City	November 8, 1969
Amherst College	December 19, 1969
Philadelphia YMHA	April 1970
Rutgers University	November 6, 1970
Whitney Museum of Art, New York City	March 31, 1970
	April 1, 2, 1970
University of Cincinnati	Date Unknown
Montreal Festival	Date Unknown
New York University	Date Unknown
St. Peters Church	Date Unknown
New York City lofts	Date Unknown

1971

11–12th St. Series, New York City	Date Unknown
Black Panther Fund Rally	
New York University	January 14, 1971
13th St. loft performances	February 1971
Laura Dean's loft, New York City	April 1971
New York City Dance Marathon, YMHA	May 1971
Walker Art Center, Minneapolis	July or August 1971
San Francisco Art Institute	July or August 1971

1972

Oberlin College	January 3–22, 1972
112 Green Street, New York City	February 6, 1972
SUNY, Stony Brook	May 6, 1972
Lo Giudice Gallery Series	May 28–31, 1972

1973

Dance Gallery Series (17 performances)	April/May 1973
Buffalo State College	September 22–24, 1973

1974

Contemporanea Festival, Rome	January 6–9, 1974
University of Pennsylvania	February 9–10, 1974
San Diego State University	February 24–28, 1974
University of Iowa	March 8–9, 1974
Pratt Institute	May 1, 1974
SUNY, Stony Brook	May 4, 1974
Barnard College	May 8, 1974
The Kitchen Center	May 27–28, 1974
Lewiston State Art Park, New York	Summer 1974
Wolftrap Farm Park, Washington, D.C.	August 22, 1974

1975

La Mama Annex, New York City	March 14–16, 1975
Moming, Chicago	October 10–13, 1975
Walker Art Center, Minneapolis	October 4–9, 1975
Seibu Theater, Tokyo	December 12–17, 1975

1976

La Mama Annex, New York City	April 22–25, 1976
University of California, Santa Barbara	April 29, 1976
University of California, Los Angeles	May 3, 1976
University of Montana, Missoula	May 8–10, 1976

BIBLIOGRAPHY

General Background

Banes, Sally. *Terpsichore in Sneakers: Post-Modern Dance*. Boston: Houghton Mifflin Co., 1980.

Banes, Sally, Jill Johnston, and the Bennington College Judson Project. *Judson Dance Theatre: 1962–1966*. Bennington, VT: Bennington College, 1981.

Battcock, Gregory, ed. *Minimal Art*. New York: E. P. Dutton & Co., 1966.

---. *The New Art: A Critical Anthology*. New York; E. P. Dutton & Co., 1946.

Breder, Hans, and Stephen C. Foster, eds. *Intermedia*. Iowa City: Corroboree: Gallery of New Concept, U of Iowa, 1979.

Brook, Peter. *The Empty Space*. New York; Atheneum, 1982.

Brown, Jean Morrison, ed. *The Vision of Modern Dance*. Princeton: Princeton Book Co., 1979.

Cage, John. *Silence*. Middletown, CT: Wesleyan UP, 1961.

---. *A Year from Monday*. Middletown, CT: Wesleyan UP, 1967.

Carroll, Noel. "Post-Modern Dance and Expression." *Philosophical Essays in Dance*, ed. Gordon Fancher and Gerald Meyers. Brooklyn: Dance Horizons, 1981. 95–104.

Cheney, Gay, and Janet Strader. *Modern Dance*. Boston: Allyn & Bacon, 1971.

Copeland, Roger, and Marshall Cohen, ed. *What Is Dance?* New York: Oxford UP, 1983.

Croce, Arlene. "Going in Circles." *New Yorker*, 12 April 1975. Reprinted in Croce, *Afterimages*. New York: Vintage Books, A Division of Random House, 1979.

Cunningham, Merce. *Changes: Notes on Choreography*, ed. Francis Starr. New York: Something Else Press, 1968.

Denby, Edwin. *Dancers, Buildings, and People in the Streets*. New York: Horizon, 1965.

---. *Looking at the Dance*. New York: Horizon, 1968.

Forti, Simone. *Handbook in Motion*. Halifax: Press of the Nova Scotia College of Art and Design; New York: New York UP, 1974.

Foster, Stephen, and Rudolf Keenzler, eds. *Data Spectrum: The Dialectics of Revolt*. Madison, WI: Coda Press; Iowa City: U of Iowa, 1979.

Ghiselin, Brewster, ed. *The Creative Process*. Berkeley: U of California P, 1952.

Goffman, Irving. *Frame Analysis*. New York: Harper & Row, 1974.

---. *The Presentation of Self in Everyday Life*. New York: Doubleday & Co., 1959.

Goldberg, Rosalee. *Performance Art from Futurism to the Present*. New York: Harry N. Abrams, Inc., 1988.

Gordon, David. "It's About Time." *The Drama Review* 19.1 (T-65, March 1975): 43–52.

Hall, James, and Barry Ulanov, ed. *Modern Culture and the Arts*. 2nd ed. New York: McGraw-Hill, 1972.

Halprin, Lawrence. *The RSVP Cycles: Creative Processes in the Human Environment*. New York: George Braziller, 1969.

Halprin, Lawrence, and Jim Burns. *Taking Part, a Workshop Approach to Collective Creativity*. Cambridge: The MIT Press, 1974.

Hanna, Judith Lynn. *The Performer-Audience Connection*. Austin: The U of Texas P, 1983.

Hansen, Al. *A Primer of Happenings and Time/Space Art*. New York: Something Else Press, 1966.

Hawkins, Alma. *Creating Through Dance*. Englewood Cliffs, NJ: Prentice-Hall, 1964.

Humphrey, Doris. *The Art of Making Dances*. New York: Holt, Rinehart & Winston, 1959.

Johnston, Jill. *Marmalade Me*. New York: E. P. Dutton, 1971.

---. "The New American Modern Dance." *The New American Arts*, ed. Robert Kostelanetz. New York; Collier Books, 1967. 162–93.

Jowitt, Deborah. *Dance Beat: Selected Views and Reviews, 1967–1976*. New York: Marcel Dekker, 1977.

Kirby, Michael. *The Art of Time*. New York: E. P. Dutton, 1969.

---. *Happenings*. New York: E. P. Dutton, 1966.

Klosty, James, ed. *Merce Cunningham*. New York: E. P. Dutton, 1975.

Kostelanetz, Richard. *The Theatre of Mixed Means*. New York: Dial P, 1968.

Langer, Suzanne. *Feeling and Form: A Theory of Art Developed from Philosophy in a New Key*. New York: Charles Scribner's Sons, 1953.

---. *Problems of Art*. New York: Charles Scribner's Sons, 1957.

Livet, Anne, ed. *Contemporary Dance*. New York: Abbeville P, 1978.

Lockhart, Aileene, and Esther E. Pease. *Modern Dance*. 4th ed. New York: Wm. C. Brown Co., 1976.

May, Rollo. *The Courage to Create*. New York: Bantam Books, 1975.

McDonagh, Don. *The Rise and Fall of Modern Dance*. New York: Outerbridge and Drinstfrey, 1970.

McDonagh, Don. "Yvonne Rainer." *The Complete Guide to Modern Dance.* New York: Doubleday, 1976. 445–48.

Mettler, Barbara. *Materials of Dance as a Creative Art Activity.* Tucson, AZ: Mettler Studios, 1960.

Moustakas, Clark. *Creativity and Conformity.* New York: Van Nostrand Reinhold Co., 1967.

Rainer, Yvonne. *Work 1961–73.* Halifax, Nova Scotia: P of the Nova Scotia College of Art and Design; New York: New York UP, 1974.

Rose, Barbara. *American Art Since 1900.* New York: Praeger, 1967.

Roszau, Theodore. *The Making of Counter Culture.* New York: Anchor Books, 1968.

Sayre, Henry M. *The Object of Performance, the American Avant-Garde Since 1970.* Chicago and London: U of Chicago P, 1989.

Schechner, Richard. *The End of Humanism.* New York: Performing Arts Journal Publications, 1982.

---. *Environmental Theater.* New York: Hawthorn Books, 1973.

---. *Essays on Performance Theory 1970–1976.* New York: Drama Book Specialists, 1977.

Schechner, Richard, and Mady Schuman, eds. *Ritual, Play, and Performance.* New York: Seabury P, 1976.

Schneemann, Carolee. *More Than Meat Joy.* New Paltz, NY: Documentext, 1979.

Siegel, Marcia. *At the Vanishing Point.* New York: Saturday Review P, 1972.

---. *The Shapes of Change: Images of American Dance.* Boston: Houghton Mifflin, 1979.

---. *Watching the Dance Go By.* Boston: Houghton Mifflin Co., 1977.

Sohn, H. *Happenings and Fluxus.* Cologne: Koelnischer Kunstverin, 1970.

Steinberg, Cobbett, ed. *The Dance Anthology*. New York: New American Library, 1980.

Stone, I. F. *In a Time of Torment*. New York: Vintage Books, 1968.

Terry, Walter. *The Dance in America*. Rev. ed. New York: Harper & Row, 1973.

Tompkins, Calvin. *The Bride and the Bachelors*. New York: Viking P, 1968.

---. *Off the Wall: Robert Rauschenberg and the Art World of Our Times*. New York: Penguin Books, 1981.

Watts, Alan. *The Way of Zen*. New York: Random House, 1957.

Journals and Magazines

Anderson, Jack. "New York." *Dancing Times* (London), 31 April 1973.

---. "Yvonne Rainer: The Puritan as Hedonist." *Ballet Review* 2.5 (1969): 31–37.

Baker, Robb. "Grand Union: Taking a Chance on Dance." *Dance Magazine* Oct. 1973: 41–46.

---. "Mary Hartman, Mary Hartman." *Dance Magazine* Aug. 1976: 20–22.

---. "New Dance." *Dance Magazine* Aug. 1974: 70–72.

Banes, Sally. "Steve Paxton: Physical Things." *Dance Scope* 13 (Winter/Spring 1979): 11–25.

Banes, Sally, and Noel Caroll. "Working and Dancing: A Response to Monroe Beardsley's 'What Is Going On In a Dance?'" *Dance Research Journal* 15.1 (Fall 1982): 37–41.

Bear, Liza, and Willoughby Sharp. "The Performer as a Persona: An Interview with Yvonne Rainer." *Avalanche* no. 5 (Summer 1972): 46–59.

Beardsley, Monroe. "What Is Going on In a Dance?" *Dance Research Journal* 15.1 (Fall 1982): 31–36.

160

Bernan, Susan. "Yvonne Rainer." *Ms* Apr. 1975.

Borden, Lizzie. "Trisha Brown and Yvonne Rainer." *Artforum* June 1973: 79–81.

Brown, Trisha, and Douglas Dunn. "Dialogue: On Dance." *Performing Arts Journal* 1 (Fall 1976): 76–83.

Carroll, Noel. "Air Dancing." *The Drama Review* 19.1 (T-65, Mar. 1975): 5–12.

Celant, Germano. "Dance: The Grand Union Is a Group." *Domus* 532 (Mar. 1974): 54–55.

Croce, Arlene. "Avant-Garde on Broadway." *Ballet Review* 4.1 (1971).

---. "Dancing, Arts and Sciences and David Gordon." *New Yorker* 15 May 1978: 126–31.

---. "Profiles: Making Work." *New Yorker* 29 Nov. 1982: 51–107.

Cunningham, Merce. "The Impermanent Art." *Seven Arts* 3 (1955): 71–73.

The Drama Review: Dance/Movement Issue 24 (T-88, Dec. 1980).

Dunn, Judith. "My Work and Judson's." *Ballet Review* 1.6 (1967): 22–26.

Goodman, Saul. "Yvonne Rainer: Brief Biography." *Dance Magazine* 39 (Dec. 1965): 110–11.

Gordon, David. "It's About Time." *The Drama Review* 19.1 (T-65 (Mar. 1975): 43–52.

Grand Union. "The Grand Union." *Dance Scope* 7 (Spring/Summer 1973): 28–32.

---. "There Were Some Good Moments...." *Avalanche* 8 (Summer/Fall 1973): 40–47.

Halprin, Ann. "Ceremony of Us." *The Drama Review* 13.4 (T-44, Summer 1969): 131–38.

---. "Instructions to Performers." *The Drama Review* 13.4 (T-44, Summer 1969): 139–43.

Halprin, Ann. "The Process Is the Purpose." *Dance Scope* 4.1 (Fall/Winter 1967–68): 11–18.

Hecht, Robin Silver. "Reflections on the Career of Yvonne Rainer and the Values of Minimal Dance." *Dance Scope* 8.1 (Fall/Winter 1973–74): 12–25.

Johnston, Jill. "Rainer's Muscle." *Eddy* Spring/Summer 1976: 36–40.

Kendall, Elizabeth. "Grand Union: Our Gang." *Ballet Review* 5.4 (1975–76): 44–55.

Koch, Stephen. "Performance, A Conversation." *Artforum* 11 (Dec. 1972): 53–58.

Kostelanetz, Richard. "Metamorphosis in Modern Dance." *Dance Scope* 5 (Fall 1970): 6–21.

Levin, David M. "Performance." *Salmagundi*, no. 31–32 (Fall 1975-Winter 1976): 120–42.

Lugar, Eleanor Rachel. "A Contact Improvisation Primer." *Dance Scope* 12 (Fall/Winter 1977–78): 48–56.

McDonagh, Don. "Notes on Recent Dance." *Artforum* Dec. 1972: 48–52.

Michelson, Annette. "Yvonne Rainer, Part One: The Dancers and the Dance." *Artforum* Jan. 1974: 57–63.

---. "Yvonne Rainer, Part Two: Lives of Performers." *Artforum* 12 (Feb. 1974): 30–35.

Morris, Robert. "Notes on Dance." *Tulane Dance Review* (Winter 1975): 177–86.

Nuchtern, Jean. "Moods." *Dance Magazine* May 1975.

Paxton, Steve. "Contact Improvisations." *The Drama Review* 19.1 (T-65, Mar. 1975): 40–43.

---. "The Grand Union Improvisational Dance." *The Dance Review* 16 (Sept. 1972): 128–34.

Pops, Martin Leonard, ed. *Dance, Salmagundi*, no. 33–34 (Spring/Summer 1976).

Rainer, Yvonne. "Backwater: Twosome/Paxton and Moss." *Dance Scope* 13.2&3 (Winter/Spring 1979).

---. "Editor's Forum." *Dance Magazine* 46 (Oct. 1972): 100.

---. "Engineering Calamity with Trisha Brown: An Interview." *Update, Dance/USA* Oct. 1986: 20–22.

---. "Paxton Untitled." *Soho Weekly News* 16 Nov. 1978: 31. Reprinted in *Dance Scope* 13 (Winter/Spring 1979): 8–10.

---. "A Quasi Survey of Somme 'Minimalist' Tendencies in the Quantitatively Minimal Dance Activity Midst the Plethora, or an Analysis of Trio A." *Minimalist Art*, ed. Gregory Battock. New York: E. P. Dutton, 1968. 263–73.

---. "Some Retrospective Notes on a Dance for 10 People and 12 Mattresses Called 'Parts of Some Sextents' Performed at the Wadsworth Atheneum, Hartford, Connecticut, and Judson Memorial Church, New York, March 1965." *Tulane Drama Review* 10 (Winter 1965): 168–78.

Rainer, Yvonne with Ann Halprin. "Yvonne Rainer Interviews Ann Halprin." *Tulane Drama Review* 10 (Winter 1965): 142–67.

Reich, Steve. "Notes on Music and Dance." *Ballet Review* (1973).

Robertson, Allen. "Newer Than New, the Post-Modern Choreographers." *Ballet News* (New York) 3.4 (Oct. 1981): 20–22.

Smith, Karen. "David Gordon's 'the Matter.'" *The Drama Review* 16.3 (T-55, Sept. 1972): 117–27.

Sommer, Sally R. "Trisha Brown Making Dances." *Dance Scope* 11.2 (Spring/ Summer 1977): 7–18.

Newspaper Articles and Reviews

Bream, Jon. "Six Individuals Build Disappointing Dance in Loose Collaboration."
Minneapolis Star 10 Oct. 1975.

Duncan, Kathy. "Grand Union." *Soho Weekly News* 13 June 1974.

Dunn, Douglas, and Robert Pierce, ed. "The Grand Union, Critics and Friends."
Soho Weekly News 29 Apr. 1976.

Goldner, Nancy. "Dance." *The Nation* 12 Apr. 1975.

Jowitt, Deborah. "Company Spirit." *Village Voice* 1 Apr. 1971.

---. "The Grand Union." *Village Voice* 24 May 1973.

---. "Pull Together in These Distracted Times." *Village Voice* 31 Mar. 1975.

---. "Yvonne Say." *Village Voice* 14 Jan. 1971.

Kisselgoff, Anna. "Casual Nude Scene Dropped into Dance by Rainer Company."
New York Times 16 Dec. 1970: 51.

Klein, Peter, and Felicity Brock. "Ongoing Story of a Grand Union: Interaction
and Trust in Dance." *Oberlin Review,* 21 Jan. 1972.

Kriegsman, Alan. "When Dance Becomes Theater." *Washington Post,* 24 Nov.
1985.

Lewis, Jean Battey. "Half Missed the Best Half." *Washington Post* 23 Aug. 1974.

McDonagh, Don. "Dance Series Moves Into a Final Phase." *New York Times* 17
May 1971: 42.

---. "Choreographers in Humorous Bill." *New York Times* 30 May 1972.

---. "Grand Union Offers Unstructured Dance Experience." *New York Times*
3 Apr. 1973.

---. "Grand Union's Skits Now More Formula Than Improvisation." *New York
Times* 23 Apr. 1976.

Meersman, Roger. "Lifeless Living Theater." *Sentinel* (Montgomery County, MD) 28 Aug. 1974.

Mekas, Jonas. "Movie Journal." *Village Voice* 4 May 1972.

Perron, Wendy. "People Improvisation." *Soho Weekly News* 6 May 1976.

Robertson, Allen. "Grand Union." *Minneapolis Daily* 17 Oct. 1975.

Rockwell, John. "Disciplined Anarchists of Dance." *New York Times* 18 Apr. 1976.

Sainer, Arthur. "Grand Union." *Village Voice* 3 May 1976.

Segal, Lewis. "Improvisation by Grand Union." *Los Angeles Times* 4 May 1976.

Siegal, Marcia. "On Dance—Did Anyone See My Monster Dress?" *Soho Weekly News* 27 Mar. 1975.

Steele, Mike. "Grand Union." *Minneapolis Tribune* 7 Oct. 1975.

---. "Grand Union Performs at Walker." *Minneapolis Tribune*, 29 May 1971.

Supree, Burt. "High Rollers." *Village Voice* 14 Feb. 1984.

Webster, Daniel. "Yvonne Rainer Welcomes Amateur Dancers in Group." *Philadelphia Inquirer* 9 Apr. 1970.

Interviews

Brown, Trisha. Interviewed by Sally Banes, 15 Mar. 1977.

Dilley, Barbara. New York City. Interviewed by Margaret Ramsay, Nov. 1984.

Dunn, Douglas. Interviewed by Barbara Woehler, 1979.

Dunn, Douglas. New York City. Interviewed by Margaret Ramsay, Nov. 1983.

Forti, Simone. New York City. Interviewed by Margaret Ramsay, Mar. 1985.

Gordon, David. Interviewed by Sally Banes, Apr. 1975.

Gordon, David. New York City. Interviewed by Margaret Ramsay, Mar. 1985.

Green, Nancy. New York City. Interviewed by Margaret Ramsay, Nov. 1984.

Hoover, Bruce. New York City. Interviewed by Margaret Ramsay, Mar. 1985.

Lepkoff, Danny. New York City. Interviewed by Margaret Ramsay, Feb. 1986.

Martin, Nina. New York City. Interviewed by Margaret Ramsay, Feb. 1986.

Overlie, Mary. New York City. Interviewed by Margaret Ramsay, May 1983 and
Feb. 1986.

Paxton, Steve. New York City. Interviewed by Margaret Ramsay, Dec. 1984.

Weil, Suzanne. Washington, D.C. Telephone interview by Margaret Ramsay,
Apr. 1985.

Other Sources

Banes, Sally. "Judson Dance Theatre: Democracy's Body, 1962–64." Diss. New
York U, 1980.

Dunn, Douglas, Barbara Dilley, Yvonne Rainer, and Steve Paxton. "Some Things
We've Done and Some Things I'd Like to Do at Gatherings of the Grand
Union." Performing Artservices Archives, unpublished ms., Dec. 1970.

Father Love, Joseph. "Surprising Differences—Tensions and Relaxation in Post-
Modern Dance." Performing Artservices Archives, unpublished ms., n.d.

Foreman, Richard. "Observation by Others re the Grand Union." Performing
Artservices Archives, unpublished paper, 1971.

Morris, Robert. "Clean Movement Clear Times and Clean Underwear."
Performing Artservices Archives, unpublished ms., n.d.

---. Unpublished notes on Grand Union. Performing Artservices Archives, n.d.

---. Unpublished notes on the workshop at James Waring's studio, 30 Oct. 1962.
Cited in Sally Banes, "Judson Dance Theatre: Democracy's Body, 1962–64."
Diss. New York U, 1980.

166

Performing Artservices Archives. Biographies of Yvonne Rainer, Steve Paxton, Douglas Dunn, David Gordon, Barbara Dilley, Nancy Green, and Trisha Brown.

---. Collection of Grand Union programs, rehearsal schedules at residencies, personal statements of Grand Union's work by Grand Union members.

---. *Grand Union Episodes*. Descriptions of performance events and segments, author unknown.

---. Letter sent to Brenda Way, Oberlin College, by Grand Union member, 5 Nov. 1971.

---. Miscellaneous handwritten notes on performances, author unknown.

---. Report issued on Dance Galley series, "The Grand Union and Friends and Associates in Two Months of Performing and Carrying On," submitted by Narrye Caldwell. June 1973.

Sommer, Sally. Unpublished ms. based on observation of Grand Union performances, n.d.

Video and Audio Tapes

Audio tape of meeting between Grand Union and a group of dance critics. Robb Baker, Carolyn Brown, Kathy Duncan, John Howell, James Klosty, Deborah Jowitt, Andy Mann, Robert Pierce, Sara Rudner, Valda Setterfield, Marcia Siegel and Grand Union members Trisha Brown, Barbara Dilley, Douglas Dunn, David Gordon and Nancy Green. Steve Paxton was absent, Oct. 1974.

"Beyond the Mainstream," a television dance special, May 1980. The Dance Collection, New York Public Library, New York City, New York.

Sommer, Sally R. Audio tape description of performance at Lo Guidice Gallery, Apr. 1972.

Video tape of performance at Guthrie Theatre, Minneapolis, MN, Oct. 1975. The Dance Collection, New York Public Library, New York City, New York.

Video tape of performance at Lo Guidice Gallery, New York City, Apr. 1972. The Kitchen, New York City, New York.

Video tape of performance at Seibu Theater, Tokyo, Japan. Dec. 1975. The Dance Collection, New York Public Library, New York City, New York.

INDEX OF NAMES

*Because the members of Grand Union are present on almost every page of the book (either as subject or reference), I have indexed only the pages devoted specifically to each member.

ILLUSTRATIONS

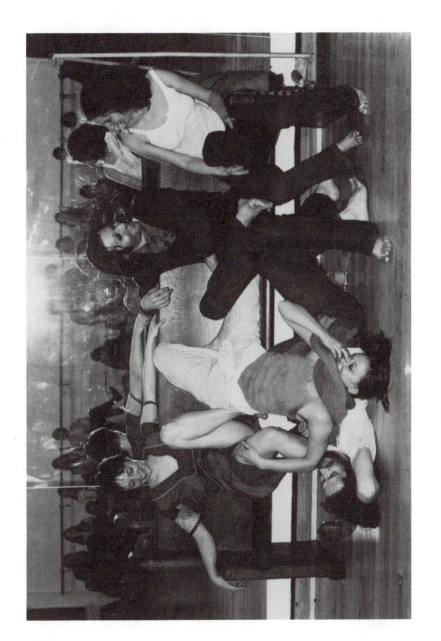

Grand Union: Barbara Dilley, Steve Paxton, Yvonne Rainer, David Gordon, Trisha Brown. Photo by Cosmos.

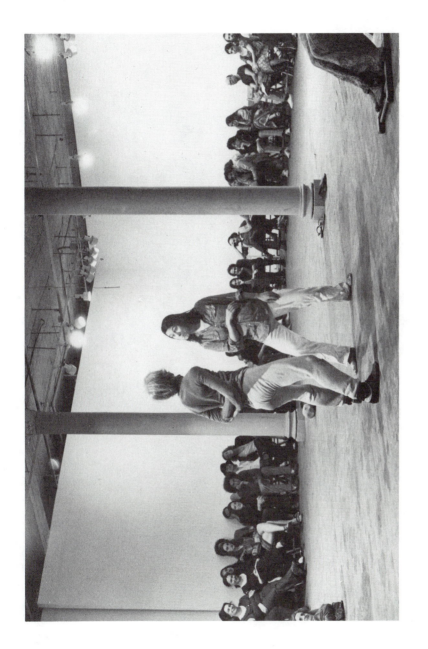

Grand Union: Douglas Dunn and Yvonne Rainer.
Photographer unknown.

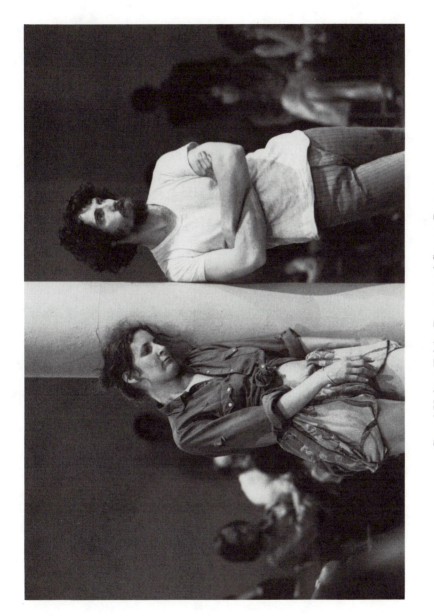

Grand Union: Trisha Brown and Steven Paxton.
Photographer unknown.

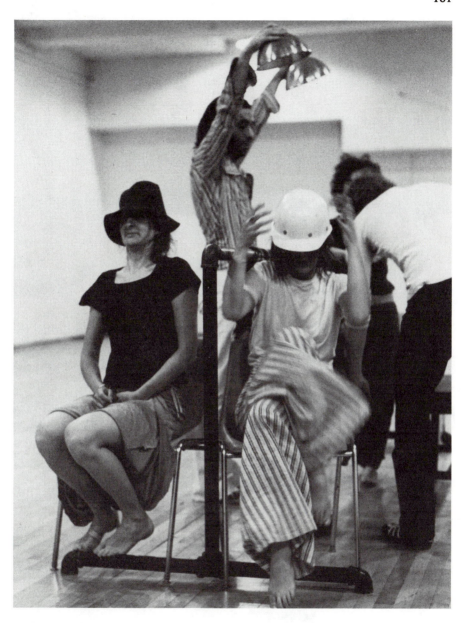

Grand Union: Trisha Brown, David Gordon, Yvonne Rainer.
Photo by Narrye Davis Caldwell.

183

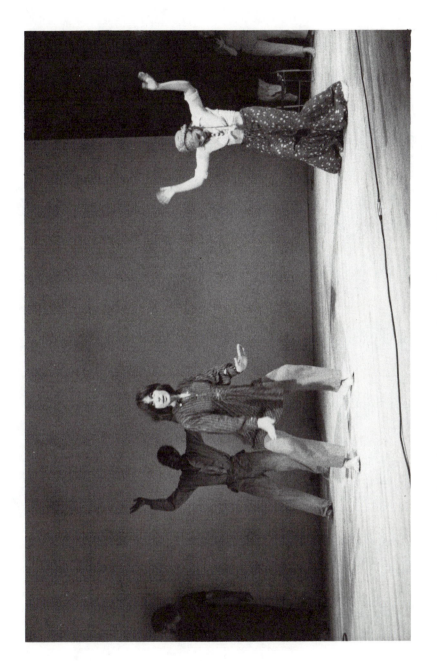

Grand Union: Dong, Yvonne Rainer, Barbara Dilley.
Photo by Tom Berthiaume.

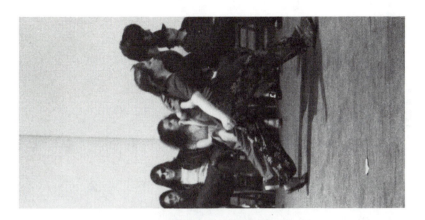

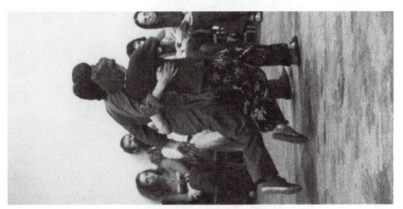

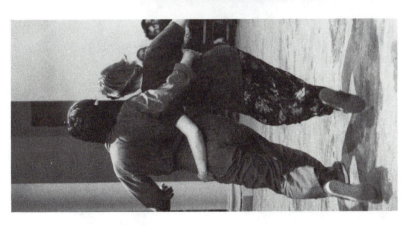

Grand Union: David Gordon and Barbara Dilley.
Photographer unknown.

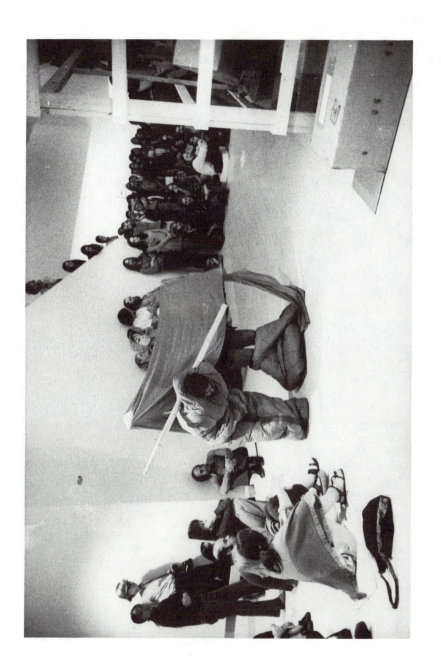

Grand Union: Photo by Tom Berthiaume.

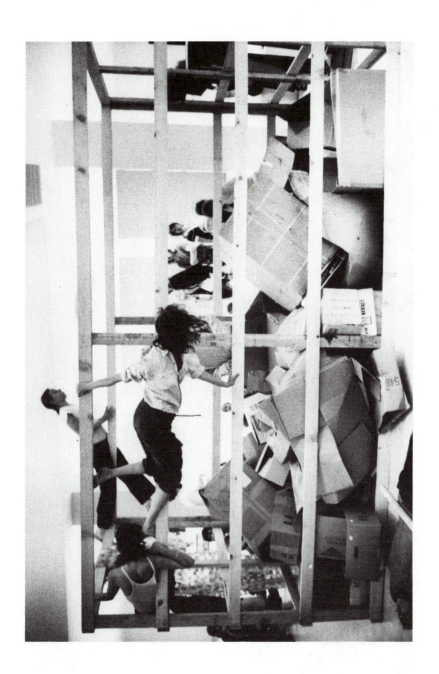

Grand Union: Photo by Tom Berthiaume.

Grand Union: David Gordon and Trisha Brown.
Photo by Al Katz.

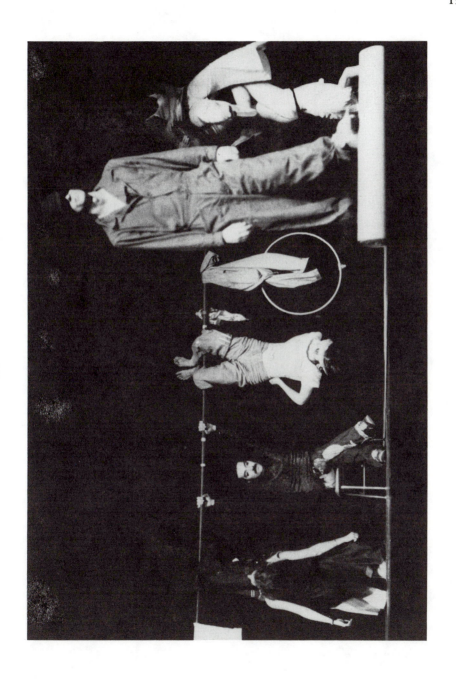

Grand Union

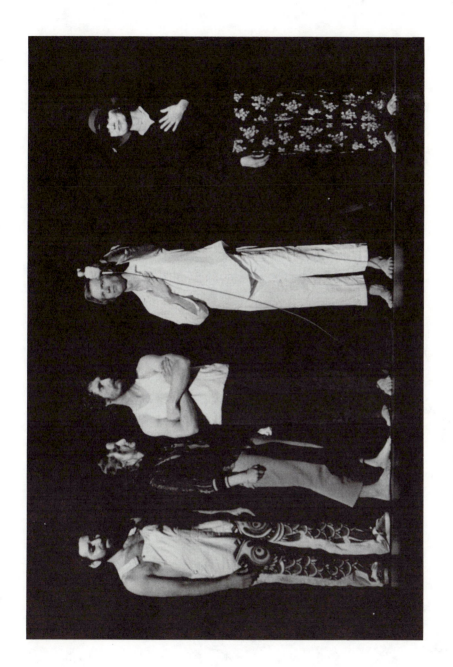

Grand Union: David Gordon, Trisha Brown, Steve Paxton, Douglas Dunn, Nancy Green